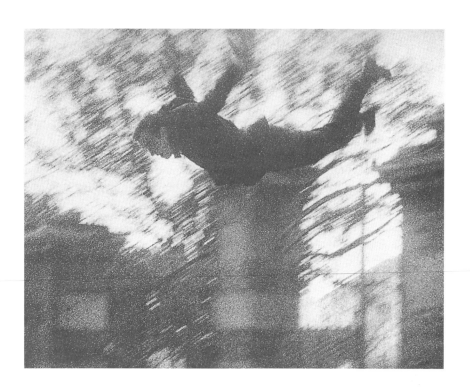

Yves Klein

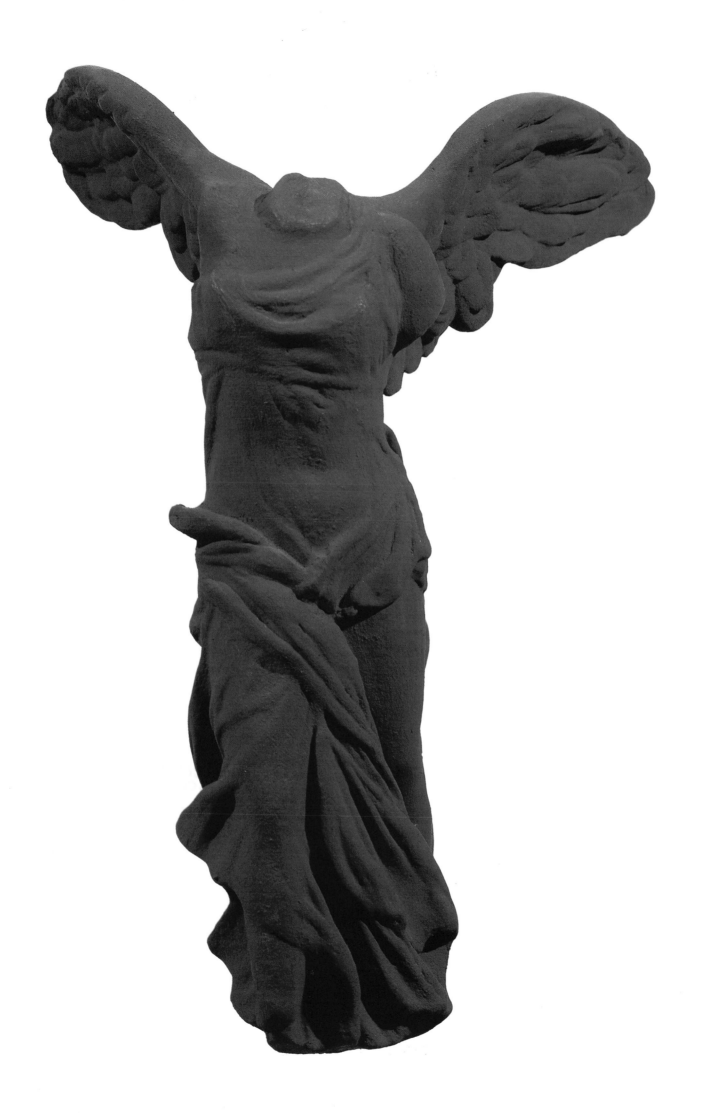

Hannah Weitemeier

YVES KLEIN
1928–1962

International Klein Blue

Benedikt Taschen

FRONT COVER:
RE 19 (detail), 1958
Sponges, pigment and synthetic resin
on hardboard, 200 x 165 cm
Cologne, Museum Ludwig

PAGE 1:
Yves Klein making his leap into the void, 1960

PAGE 2:
S 9, The Victory of Samothrace, 1962
Pigment and synthetic resin on plaster,
mounted on stone base, height 51.4 cm
Private collection

BACK COVER:
Harry Shunk
*Man in Space! The Painter of Space
Throws Himself into the Void!*, 1960
Photomontage
Private collection

**This book was printed on 100% chlorine-free bleached
paper in accordance with the TCF standard.**

© 1995 Benedikt Taschen Verlag GmbH
Hohenzollernring 53, D-50672 Köln
© 1994 for the illustrations of Yves Klein: Daniel Moquay, Paradise Valley, AZ
© 1994 for the illustrations of Jean Tinguely,
Robert Rauschenberg, Henri Matisse, Jacques de la Villeglé,
Mark Rothko: VG Bild-Kunst, Bonn
Editor and design: Simone Philippi, Cologne
Cover design: Angelika Muthesius, Cologne
English translation: John William Gabriel, Worpswede

Printed in Germany
ISBN 3-8228-8882-6
GB

Contents

6
Yves – le Monochrome

14
"The Blue Epoch"

30
"With the Void, Full Powers"

36
The School of Sensibility

50
The Leap into the Void

68
Monochromes and Fire Paintings

80
A Life like a Continuous Note

90
Yves Klein – A Chronology

92
List of Illustrations

Yves – le Monochrome

"A new world calls for a new man" – that was the message with which Yves Klein, in the mid 1950s, took the international art world by storm. The young artist's extravagant personality and unique style had captivated Paris from his first appearance on the scene. The blue paintings – large-format canvases, sheer, meditation-inspiring surfaces suffused with the deepest hue of the sky – rapidly made him famous as "Yves – le Monochrome" far beyond the borders of France. Yet they were only the beginning of a universal quest. Perhaps sensing that his life was destined to be short – he died in 1962, at the age of 34 – Klein created over a thousand paintings in the course of only seven years. His œuvre has since been recognized as a classical achievement of modern art, firmly rooted in the Western artistic tradition and yet a source of still unexhausted innovative potential.

Clearly distinguishing between talent and genius, Klein sought something in his life "that was never born and never died," an absolute value, the Archimedean point from which the circumscribed, material world could be levered out of its immobility. The logical conclusion was to choose a point outside the limits of mundane, familiar events, and Klein set out to develop a method to find it.

"A painter ought to paint one single masterpiece: himself, perpetually... becoming a kind of generator with a continual emanation that fills the atmosphere with his whole artistic presence and remains in the air after he has gone. This is painting, the true painting of the twentieth century," Klein wrote on 7 September 1957, in his diary, posthumously published as *Mon Livre*.

Klein never learned the trade of painting; he was born to it, having, as he said, "absorbed the taste of painting with my mother's milk." His father, Fred Klein, was a landscape artist of the southern French school, and his mother, Marie Raymond, belonged to the vanguard of *l'art informel* in Paris.

Yves was born in the house of his grandparents in Nice, on 28 April 1928. His boyhood was marked, on the one hand, by the atmosphere of freedom that prevailed in the continually changing circle of his parents, who from 1930 to 1939 lived mostly in Paris, but spent their summers among artist friends at Cagnes-sur-Mer. On the other hand, from the time of his birth Yves also experienced the constant loving care of his aunt, Rose Raymond, who lived in Nice and whose outlook on life, more realistic than that of her sister, led her to make the boy's everyday concerns her own. His formative years on the sunny Mediterranean were thus subject to two opposing influences: that of the *idées forcées* of the free artistic spirit Yves so admired in his parents, and that of the *élan vital* of his Aunt Rose, earthy and more oriented towards material success. In addition, the conflict his parents went through in deciding between figurative and abstract art instilled a sense of resistance in the young Yves which eventually was to lead him beyond the avant-garde issue entirely. The decision to employ color in pure form as an expression of a free-floating sensibility came at a

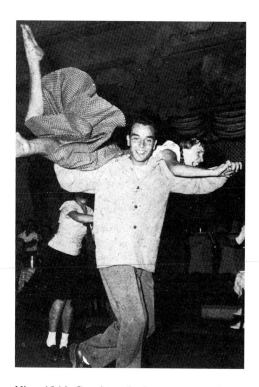

Nice, 1946: Caught up in the postwar euphoria that came with a fresh start, Klein played jazz piano, dreamed of becoming a bandleader, and danced the bebop with flair.

"Back then, as a teenager in the year 1946, I had a 'realistic-imaginative' day-dream in which I signed the far side of the vault of heaven. On that day I began to hate the birds that flew back and forth across the sky, because they were trying to punch holes in my greatest and most beautiful work."
Yves Klein, New York, 1961

very early point in his career, prompting Klein to reject line and restricting contour as an imprisonment in formal and psychological concerns, and to rely solely on the perceptions of the spirit.

Klein's first attempts to achieve the impossible were undertaken together with two friends, Armand Fernandez – who, as Arman, was to gain a reputation as the inventor of the accumulation – and the young poet Claude Pascal. The three friends met clandestinely at Arman's house, in a basement room painted blue. In a latter-day search for the philosopher's stone, they immersed themselves in esoteric literature and alchemy. They meditated on the roof of the house, and fasted one day in the week, one week every month, and one month every year – at least that was the plan. They played jazz and danced to bebop (p. 7), learned judo, and conceived of riding around the world on horseback, destination Japan. Their playful megalomania did not even stop short at the notion of dividing up the universe among themselves. Arman claimed "le plein", the riches of the earth, the abundance of material things; Claude, fledgling poet, appropriated words; and Yves characteristically chose the etherial space surrounding the planet, "le vide", the void, empty of all matter.

The boundlessness of the heavens had long been a source of inspiration to Klein. At the age of nineteen, as he lay on the beach one hot, sunny summer day in the south of France, he embarked on a "realistic-imaginary" mental journey into the blue depths. On his return he declared, "I have written my name on the far side of the sky!" With this famous symbolic gesture of signing the sky, Klein had foreseen, as in a reverie, the thrust of his art from that time onwards – a quest to reach the far side of the infinite.

The event marked the beginning of Klein's painting career, a "monochrome adventure" that began in earnest in Ireland. He and Claude Pascal went there hoping to take riding lessons, but their money ran out, Claude fell ill, and Yves was left, alone and destitute, in London. He managed to find a job as assistant to Robert Savage, a gilder and friend of his father's, who in 1949 and 1950 taught him the basics of painting, the craft of preparing grounds, rubbing pigments, and mixing varnishes. Two years later, when he finally boarded ship in 1952 for his long-awaited trip to Japan, Klein proclaimed to gathered friends that he intended to make "monochromy" the fundamental concept of his art.

The actual purpose of his stay in Japan in 1952 and 1953 was to undergo the physical and mental rigors of training in judo at the renowned Kôdôkan Institute in Tokyo. Klein's art – especially its unprecedented focus on the metaphysical – cannot be fully understood without reference to judo as a source of self-discipline, intuitive communication and a mastery of the body. Judo also helped him develop his powers of concentration and cooperation with others, and Klein achieved a Black Belt and 4th Dan grade. Through the techniques of judo, he not only learned to fight with agility, but to win with a minimal expense of effort.

After a brief stay in Madrid, Klein returned to Paris in late 1954, where his theories of monochrome painting initially found little hearing. The first Paris show of his work at the Club des Solitaires, held in 1955 under the aegis of Editions Lacoste, went almost completely unnoticed. That same year he submitted a monochrome canvas, *Expression de l'Univers de la Couleur Mine Orange*, to the Salon des Réalités Nouvelles at the Palais des Beaux-Arts de la Ville de Paris. The selection committee rejected the work, advising Klein that the addition of a second color, a point, or a line might improve it.

Still, he remained undaunted in his belief that pure color indeed represented "something" in itself. Searching for a congenial interpreter, Klein came across Pierre Restany, an art critic who spontaneously understood him, seemingly without the need for explanation. The contact with Restany was to confirm Klein's idea of "direct communication," and marked a turning-point in the acceptance and understanding of his art the effects of which continue to be felt today.

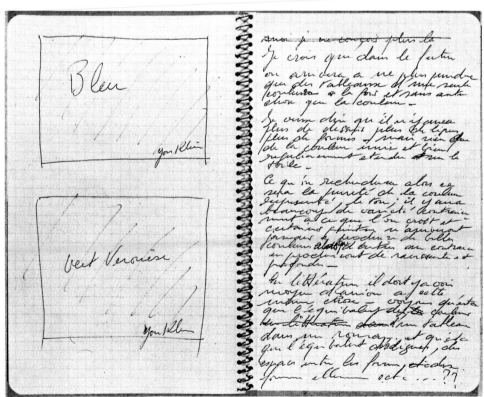

M 6, 1956

Journal entry for 27 December 1954. Klein's first experiments in monochrome painting were made in diary entries dating from as early as 1947–48. Here, he writes, "I believe that in future, people will start painting pictures in one single color, and nothing else but color…"

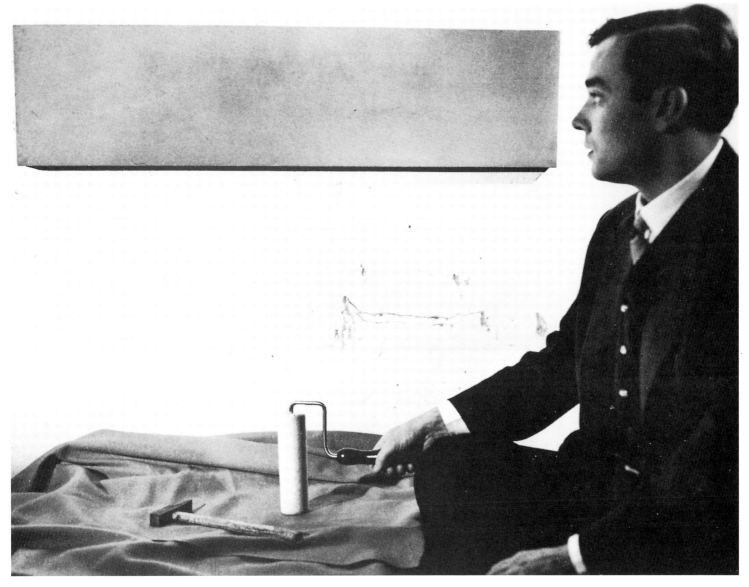

and In with Restany's help

It all began on 21 February 1956, the opening day of Klein's second Paris show, held at the Galerie Colette Allendy, a key venue of the avant-garde. With the exhibition title, "Yves: Propositions monochromes", and his catalogue introduction, "La Minute de Vérité" (The Minute of Truth), Restany set out to explain the theoretical bases of the artist's new approach. After Restany's discussion with Louis-Paul Favre was published in the daily *Combat*, the issue of an aesthetic involvement with a single color finally began to attract serious interest on the Paris art scene.

Klein became known as "Yves – le Monochrome." Asked what this, and his art, were supposed to mean, the artist used to recount an ancient Persian tale: "There was once a flute player who, one day, began to play nothing but a single, sustained, uninterrupted note. After he had continued to do so for about twenty years, his wife suggested that other flute players were capable of producing not only a range of harmonious tones, but even entire melodies, and that this might make for more variety. But the monotonous flute player replied that it was no fault of his if he had already found the note which everybody else was still searching for."

By this time, Klein had already put the parable of the flute player into practice, and not only in his painting. He had composed a symphony based on a single, vibrating note and extended silence, a two-part continuum of sound and soundlessness which, as it were, formed the overture to his artistic career. The

Yves Klein in his studio, c. 1956

PAGE 10:
M 12, 1957
In his first attempt to publicly exhibit a monochrome painting in Paris, Klein submitted a large-format work in orange to the Salon des Réalités Nouvelles in 1955. It was turned down by the selection committee, who advised him to add at least a second color, a line, or a point. Still, Klein remained convinced that color represented "something" in itself.

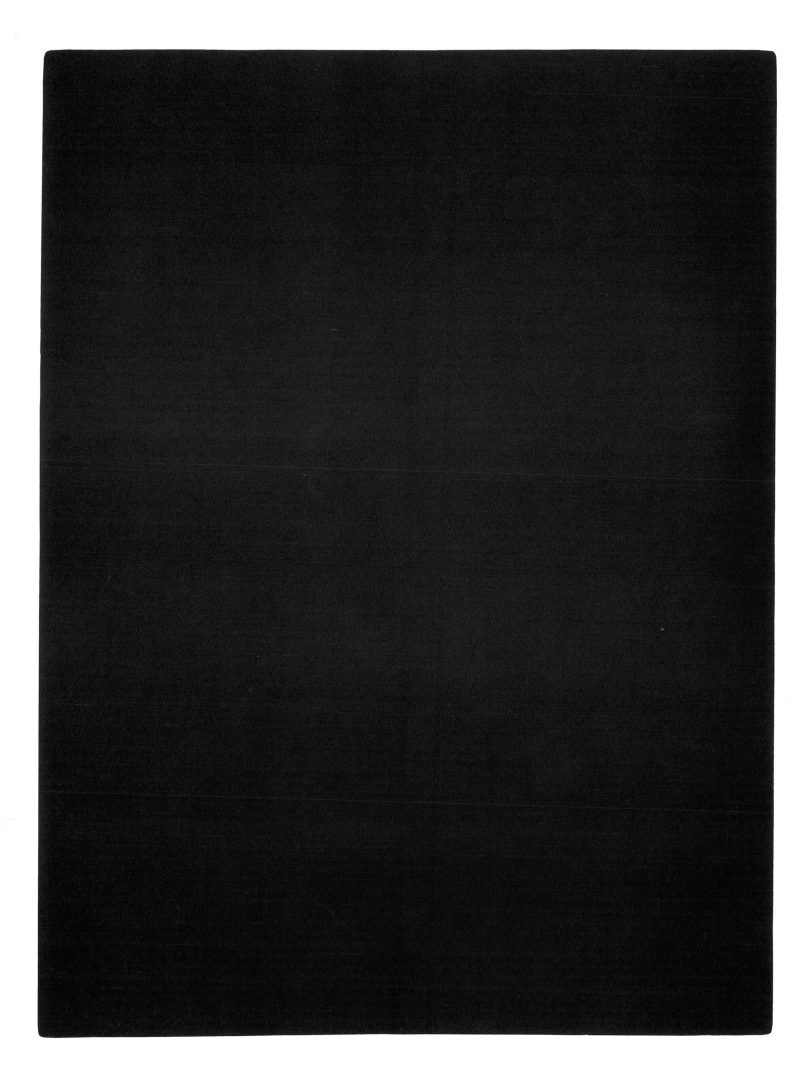

"The Blue Epoch"

With his Monochromes in a single, uncut color, Klein had established the visual effect of pure pigments. But a thorny problem remained: as soon as the dry pigment was mixed with a painting medium, its brilliancy diminished. Far from being merely a technical point, this phenomenon represented a conceptual challenge as well. Less important than achieving an aesthetic effect to Klein was the attempt to find a correspondence between color and human scale. To his way of thinking, every canvas was to possess an intensity that would draw the viewer into it, trigger his or her emotional sensibilities. For years, Klein searched for a paint formula that would help fulfil this demand.

In 1955 he found a practicable solution to the problem of color intensity, in a new chemical product marketed at that period under the name of "Rhodopas." This was a synthetic resin normally employed as a fixative. When it was thinned, Klein found, it could be used to bind pigments without materially altering their luminosity. The result was a matte, unreflecting paint that, saturating the canvas ground, produced a surface whose gently vibrant effect on the eye was akin to a double exposure, an effect Klein sometimes referred to as "a sensitized image," "poetic energy," or "pure energy." To the extent that such paintings appeared to take on a life of their own, Klein felt they represented adequate manifestations of a universal sense of space. "For me," he said at the opening of his 1955 exhibition at Editions Lacoste, "every nuance of a color is, in a sense, an individual, a living creature of the same species as the primary color, but with a character and personal soul of its own. There are many nuances – gentle, angry, violent, sublime, vulgar, peaceful." From the reactions of the audience, however, he realized that far from being able to see intentions of this nature in his work, viewers thought his various, uniformly colored canvases amounted to a new kind of bright, abstract interior decoration. Shocked at this misunderstanding, Klein knew a further and decisive step in the direction of monochrome art would have to be taken. His involvement with nuances and gradations would cease, and from that time onwards he would concentrate on one single, primary color alone: blue. This blue, eradicating the flat dividing line of the horizon, would evoke a unification of heaven and earth.

By the autumn of 1956, Klein had found what he was looking for, a saturated, brilliant, all-pervasive ultramarine he called "the most perfect expression of blue." The pigment was the result of a year of experiments, in which Klein was aided by Edouard Adam, a Paris retailer of chemicals and artists' materials. To bind the pigment and adhere it to the support, the two developed a thin solution consisting of ether and petroleum extracts. With this blue, Klein at last felt able to lend artistic expression to his personal sense of life, as an autonomous realm whose twin poles were infinite distance and immediate presence. In analogy to the overtones in music, the specific hue of the pigment engendered a visual sensation of complete immersion in the color, without compelling the viewer to define its character.

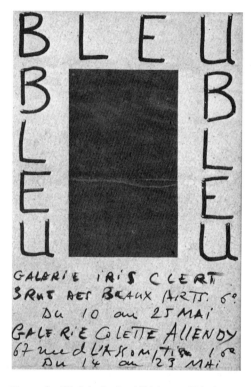

Poster for Klein's dual exhibition at Galerie Iris Clert and Galerie Colette Allendy, Paris, 1957

PAGE 14:
IKB 3, 1960
"To sense the soul, without explanation, without words, and to depict this sensation – this, I believe, is what led me to monochrome painting."
Yves Klein

Blue Reliefs: S 1, S 3, S 4, S 5, 1957
Blue, the color of the sea and sky, evokes distance, longing, infinity. "This color has a strange and almost unutterable effect upon the eye. It is, in itself, an energy ... There is something contradictory in its aspect, both stimulating and calming. Just as we perceive the depths of the sky and distant mountains as blue, a blue surface appears to recede from the eye. Just as we wish to pursue a pleasant object that moves away from us, we enjoy gazing upon blue – not because it forces itself upon us, but because it draws us after it."
Goethe, *Theory of Color*, 1810

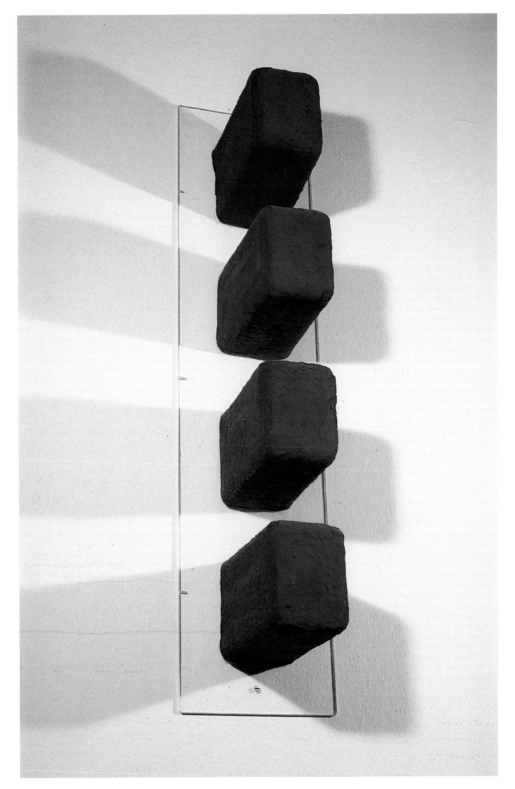

In 1957 Klein proclaimed the advent of the "Blue Epoch", sending out invitations to his dual Paris exhibition with an original *Blue Stamp*. His apotheosis of blue soon earned him an international reputation, as "Yves – le Monochrome."

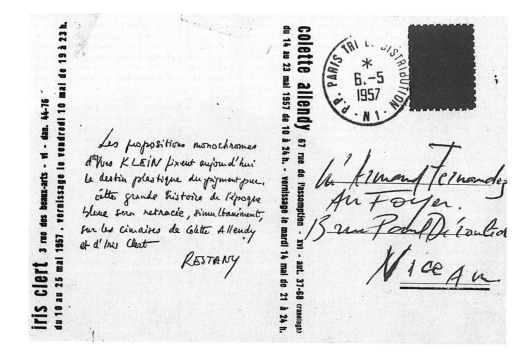

IKB 45, 1960

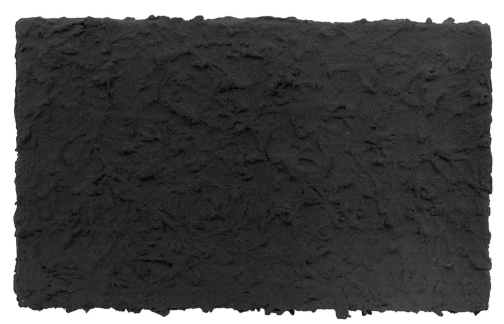

Klein's patent on *International Klein Blue* (IKB), 1960
With patent no. 63471, dated 19 May 1960, the French Patent Office officially declared the chemical composition of Klein's IKB pigment a protected invention.

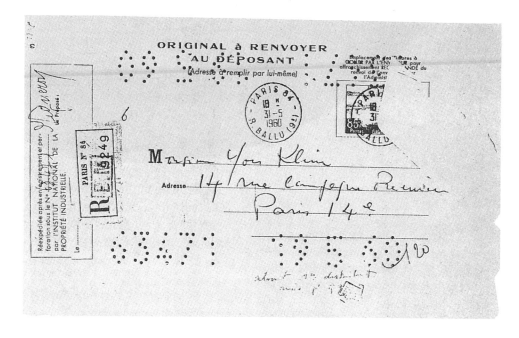

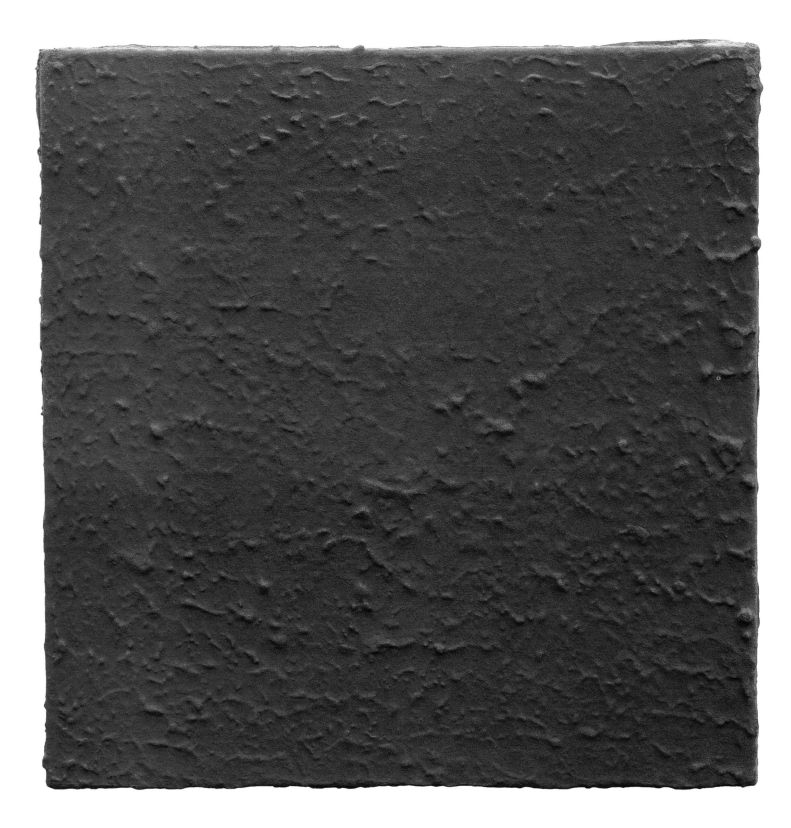

IKB 190, 1959

PAGE 23:
IKB 2, 1961

Yves Klein and Rotraut Uecker met in sum-
mer 1957 at Arman's studio in Nice. It was
the beginning of a profound love and an in-
tense artistic collaboration.

S 12, Blue Venus, undated

plate *IKB 54* (1957; p. 18) to the serrated length of wood titled *S 31* (c. 1957;
p. 19). Taken from their familiar context and reworked, the found objects were
raised to the status of art. Yet unlike the American Pop artists, who in the 1960s
would react similarly to man-made consumer products, Klein treated his finds in
a way that placed his work in a typically European context of meaning. Whether
prefabricated or natural in origin, each object was conceived and reworked in an
attempt to lend it a dynamic harmony that would stimulate individual percep-
tion, and a recognition that things habitually considered part of the external
world possessed the same fundamental structure and laws as those which govern
the individual organism. In one form or another, each piece contained covert al-
lusions to a reciprocal influence between the subjective and objective references
of a self-contained artistic universe.

Included in the Colette Allendy show were paint rollers Klein had used to
make his works, mounted on a metal frame; a five-section folding blue screen; a
blue carpet; natural sponges soaked in blue; and an evocation of blue rain (p. 20)
in the form of twelve slender dowels, about two meters in length, dangling in a
row next to the related object *Blue Trap for Lines* (p. 20). Then came a blue-
painted globe, and, scattered on the floor, blue pigment that was to be carried
around the gallery by the visitors' movements. Later, Klein was to augment this
blue universe by a few, significant works of art from Paris museums, such as
small-scale plaster replicas of *The Victory of Samothrace* (p. 2) and one of
Michelangelo's Slaves, both of them paradigms of Western culture, and both
holding a position of prominence in the Louvre.

In sum, the 1957 exhibition with Colette Allendy already embodied a confron-
tation between past and future in Klein's œuvre. Some people at the vernissage
might have suspected this when they went into the garden, where the artist had
set up a blue panel to which sixteen flares were attached, in four rows of four.
Before their astonished eyes, Klein ignited the flares, and the picture went up in
a brief but spectacular blaze. This ephemeral monochrome, titled *Bengal Flares
M 41 – One-Minute Fire Painting* (pp. 28 and 29), has since attracted much and
varied interpretation on the part of art historians. But it was not the only sur-

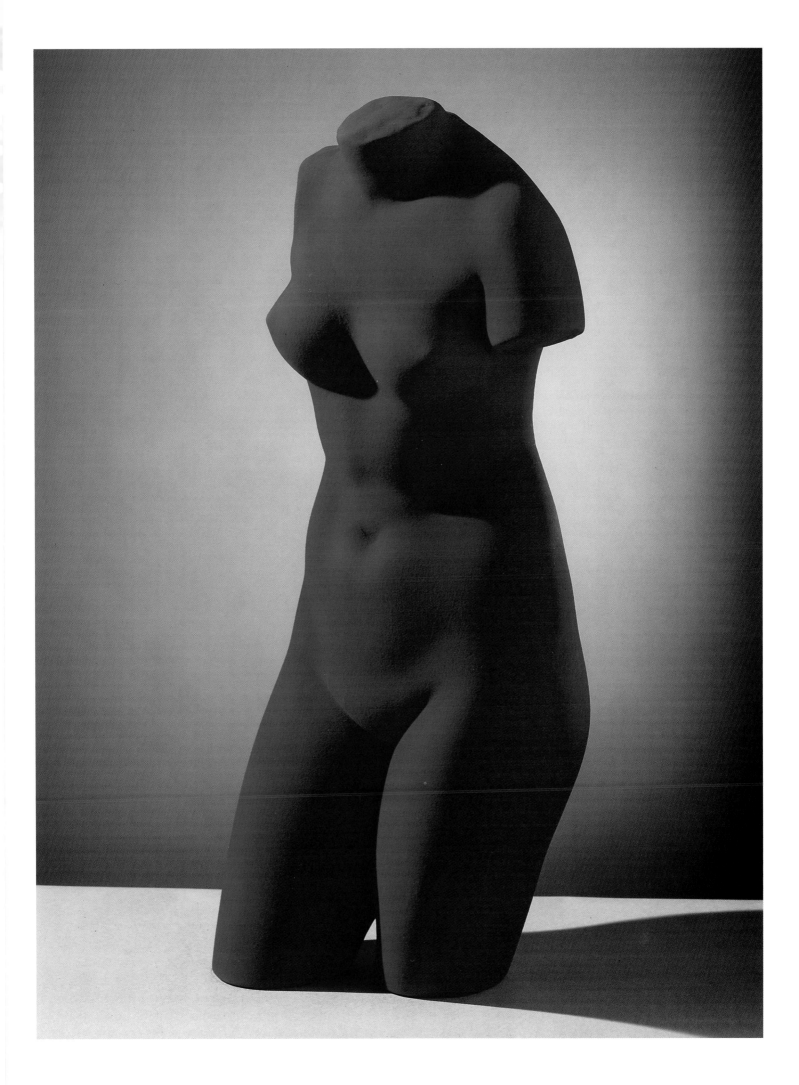

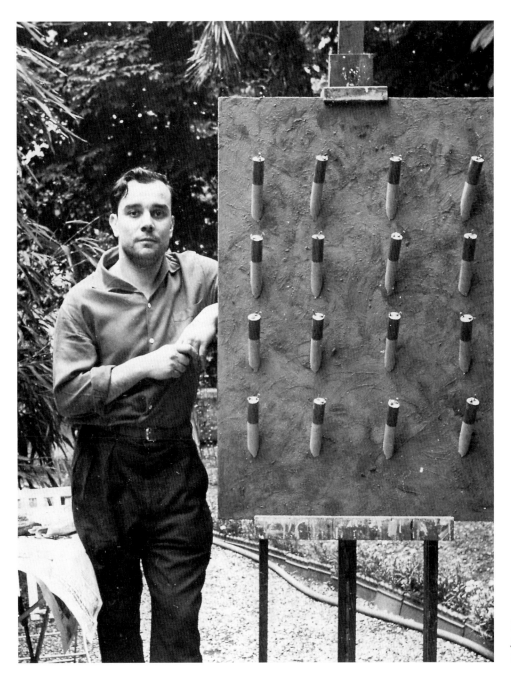

Klein in Colette Allendy's garden, with *Bengal Flares M 41 – One-Minute Fire Painting*, 1957

To recapitulate, the year 1957 marked the breakthrough of Klein's art on the European scene. At the time, this represented an extraordinary success, despite the misinterpretations – and overinterpretations – by which it was accompanied, and which Klein recorded in his journal as a chapter of contemporary history. He also documented the breakthrough in quite literal terms, in a photographic self-portrait showing him gazing through a hole cut in a monochrome canvas painted earlier that year (p. 27). With some justification he was now able to state, "I have left the problem of art behind me."

For Klein, the color blue always held associations with the sea and the sky, where the phenomena of vital, tangible nature appear in their most abstract form. "Blue has no dimensions," he noted. "It 'is' beyond the dimensions of which other colors partake." This unqualified "being" of blue was to provide the inspiration for the next phase of Klein's development, in which, conceiving of himself as a painter of cosmic space, the limits of both space and time would have to be overcome. "And let's be honest," he later said, "to paint space, I have to put myself right into it, into space itself."

PAGE 29:
Bengal Flares M 41 – One-Minute Fire Painting, 1957
"My first fire painting was a surface of Bengal flares with blue flames."
Yves Klein

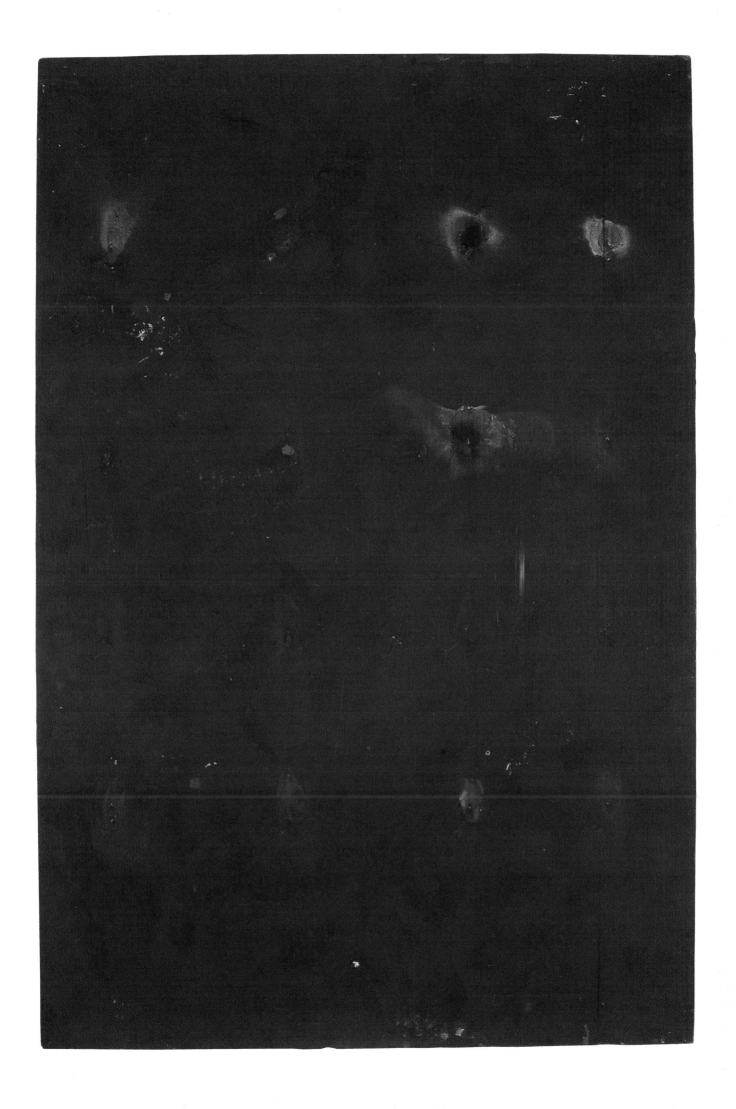

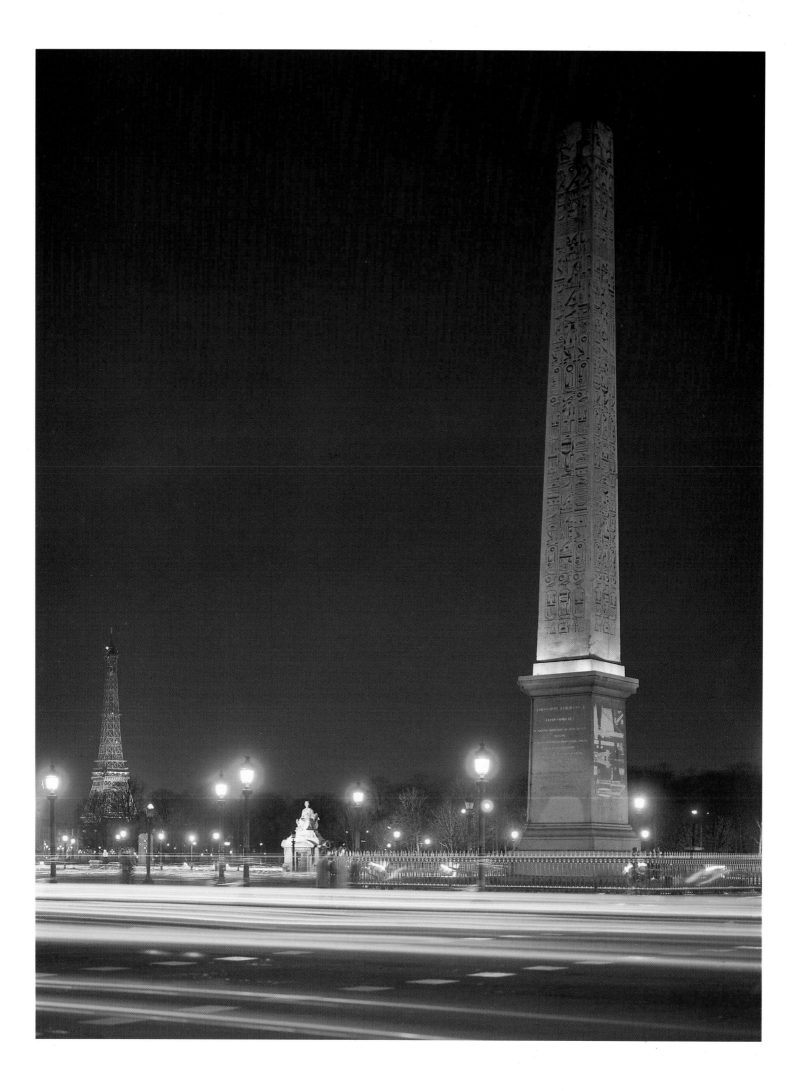

"With the Void, Full Powers"

In the early months of 1958, Klein's conviction grew that the idea for a work of art was more important than the actual, executed work itself. With great care and precise timing, he began to plan an event of a kind that no exhibition space had ever before witnessed. He intended to demonstrate the paradox that such a space could be entirely divorced from the ordinary, mundane realm of objects. As the logical consequence of the development of his painting to that point, Klein decided to exhibit nothing – at least nothing that was immediately visible or tangible. The presentation would be devoted neither to an abstract idea nor to a concrete thing, but to the *indéfinissable*, the indefinable in art, as Eugène Delacroix had called it, or the "immaterial," Klein's own term for the ever-present but ineffable aura possessed by every great work of art. As always, he chose the public setting of an art gallery for the event, which was to take place within the conventional time limits of an exhibition. With the invited guests, Klein hoped to share his new sense of universal artistic freedom, and to perpetuate it in a ritual celebration.

The exhibition, originally called "Epoque Pneumatique", but since generally known as *Le Vide* (The Void), took place on 28 April 1958, at the Galerie Iris Clert in Paris. Many legends have since arisen concerning the elaborate and painstakingly organized ritual of that evening. It truly represented an attempt to conquer uncharted territory, to capture absolute blue in empty space – "the far side of the sky."

To accompany the vernissage, a highly visible symbol was planned, a "blue project" in which the obelisk on Place de la Concorde was to be illuminated by blue floodlights (p. 30). While the pedestal was to remain in darkness, the soaring obelisk would hover over the city like a magic invocation of the past (p. 31). However, the successful trials carried out by Electricité de France did not convince the prefect of police, who withdrew his permission at the last moment.

That evening the windows of the exhibition space, at least, shone in the inimitable *International Klein Blue*. Posted next to the entrance under a huge blue canopy were two Republican Guards in full dress uniform, gatekeepers symbolizing a rite of passage into an unknown dimension. Invitations to "Epoque Pneumatique", which was intriguingly subtitled "The Specialization of Sensibility in its Primal State of Perpetual Pictorial Sensibility," doubled as vouchers worth 1500 francs, to encourage visitors' receptiveness to the presentation. Klein had removed all the furniture, even down to the telephone, from the small, 150-square-foot gallery room. Then, clearing his thoughts of everything but a focus on "pictorial sensibility," he spent forty-eight hours painting the room white, using the same medium he used for his monochrome canvases, in order to retain the luminosity and intrinsic value of this non-color.

Perhaps it was the eccentric, not to say crazy nature of the event that led it to be eagerly awaited on the Paris scene. At any rate, it attracted over 3000 people,

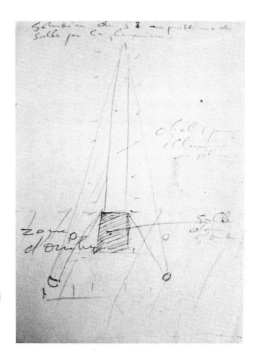

Sketch for the *Blue Obelisk* project, 1958

Posthumous realization of the *Blue Obelisk*, Place de la Concorde, Paris, 1983
Klein conceived the illuminated obelisk as a magical symbol, hovering in the night sky over the city as harbinger of his "Blue Revolution".

31

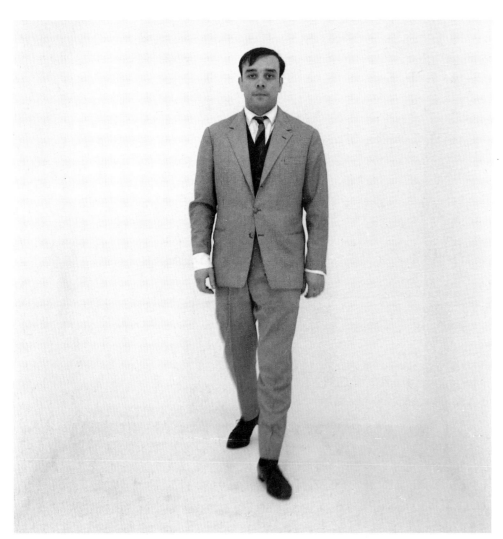

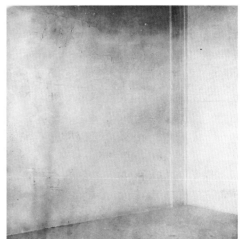

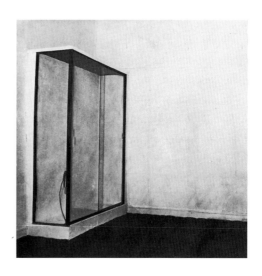

Yves Klein in *The Void*, retrospective in the Museum Haus Lange, Krefeld, 1961
"I am the painter of space. Not an abstract painter, but on the contrary, a figurative and realistic painter."
Yves Klein

The Void, Galerie Iris Clert, Paris, 1958
Top: The walls
Bottom: Glass show-case

who, each probably expecting something different, entered the silent, empty room individually or in small groups. They were offered a blue cocktail prepared specially for the show (and later reported with chagrin that it had dyed certain bodily fluids bright blue). There was a tremendous throng on opening night. Paris notables were deposited at the door by their chauffeurs. Two representatives of the Catholic Order of the Knights of St. Sebastian, which Klein had joined after the Colette Allendy show, came in elaborate regalia that contributed to the air of festive mystery. At a later stage in the evening, eye witnesses reported, two elegant Japanese ladies in magnificent kimonos arrived.

All in all, the reactions were extremely positive and encouraging. According to Klein, Iris Clert actually sold two "immaterial" works, and visitors felt inspired by the freshness of the idea. No one attempted to find parallels in contemporary art for *Le Vide*. Most simply accepted it as an opportunity to share an experience of the here and now, as the manifestation of a young artist's profound vision of a life liberated from the strictures of time and space. Whether visitors received it well or ill, Klein hoped it would bring a personal experience of art for each and all. One, the painter Wilfredo Lam, enthused that *Le Vide* had revived the "totemistic synthesis" of prehistoric times. Others spoke of a complete break with conventional humanism, and Albert Camus reacted with a poetic entry in the visitors' album: "Avec le vide les pleins pouvoirs" (With the void, full powers).

As *Le Vide* was planned to coincide with the artist's thirtieth birthday on 28 April 1957, he and his family and a few close friends celebrated the end of the remarkable event at La Coupole, a favorite artists' gathering place in Montparnasse. One of Klein's birthday presents was *L'Air et les Songes*, by the

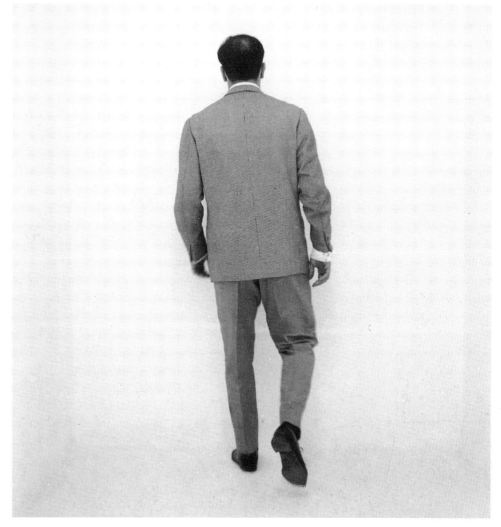

Yves Klein in **The Void**, retrospective in the Museum Haus Lange, Krefeld, 1961
"Avec le vide les pleins pouvoirs" (With the void, full powers), wrote Albert Camus in the visitors' book at the vernissage of *Le Vide*, 28 April 1958

The Void, Galerie Iris Clert, Paris, 1958
Top: The walls
Bottom: Curtains at the entrance

French philosopher Gaston Bachelard, first published in Paris in 1943. Bachelard's reflections on the realm of the air, on azure blue, and on the void as the stuff dreams are made on, were later to play a key role in Klein's own writings. The climax of the evening came with a summing-up in which the artist saluted the "Pneumatic Epoch" as a historical moment in the history of art. If the "Blue Epoch" had still been informed by the Western notion of rendering the physical body spiritual, he stated, the "Pneumatic Epoch" would pursue just the opposite goal, an incarnation of the spirit as manifested in real and practical life.

In Greek philosophy, the term pneuma bore not only the general connotation of air, but the more special meaning of a gaseous substance thought to be the cause of human breathing, and thus a vital principle, or soul-force. In Christian theology and Gnosticism, those moved by the Holy Spirit were said to have received its breath, been infused with its "pneuma". Apart from these implications, Klein used the term in his speech in a political sense, to mean a conscious emanation from himself into the world around him. The illumination of the obelisk, underscored by the idea of a "Blue Revolution" he proposed that evening in Montparnasse, were first steps towards an interim government to oversee a reorganization of the world. Klein took this vision so seriously that he soon advanced the idea to no less an authority than President Eisenhower (p. 35). Artists, believers, and scientists, he stated, should join forces to lend the world a new, more humane hue, a different radiance.

Next day, an enthusiastic review of the show appeared in the daily *Combat*. Even the general public, primed by three years of monochrome art, seemed willing to accept Klein's notion of the immaterial with an open and contemplative mind. Despite its élitist tinge, the brash self-confidence with which the artist

defended the idea was hard to resist. Even Pierre Restany was astonished at the positive response. But for weeks afterwards, he reported, his invitation text had brought him the reputation of being an oddball mystic. It ran: "Iris Clert invites you to honor, with your entire spiritual presence, the bright and positive advent of a new era of experience. This demonstration of perceptual synthesis will facilitate Yves Klein's pictorial quest for ecstatic and immediately communicable emotion."

Le Vide has inspired many and diverse interpretations, probably for the very reason that its content was so difficult to describe in words. For Klein, it marked a watershed in his life and philosophy. With a Promethean conviction of the importance of his mission, he proved that his concern lay not with aesthetic issues but with the quality of the artist's mental stance. This naturally placed great demands on the viewer's habitual perception, and required a degree of emotional empathy which was perhaps unprecedented in art. With baffling logic and radical consistency, Klein had begun to override the boundaries between subjective and objective values, opening up an unheard-of potential for the artist to embody himself in his art. By means of an art that, although merely verbally proclaimed, was ritualized down to the last detail, an art that with time would be inexorably reduced and concentrated solely in the medium of his own persona, Klein sought to make painting an integral part of human life, beyond conventional dualisms. Disregarding formal, aesthetic issues, he was concerned solely with finding answers that would further an evolutionary development. "Merely saying or writing that I have overcome the problems of art is not enough," he stated. "You really must have done so. And I have done it. For me, painting is no longer a function of the contemporary eye – it is a function of the only thing in us that does not belong to us: our LIFE!"

The relationship between art and life, always one of the central themes of painting, had traditionally been characterized by the personal bond between an artist and his work. In Klein's case, a concentration on the œuvre gradually gave way to an immersion in a universal, all-encompassing sensibility. After initial explorations of the full range of color, he reduced his palette to the single color of blue. Then, taking what seemed to be the only logical step, he embraced the concept of the void. This, to his way of thinking, was no mere vacuum or empty space; it represented a state of openness and liberty, a kind of invisible force-field. In addition, it was pervaded by a fundamental element, air, or pneuma, the medium of the energy the space contained. Klein's notion of a pneumatic space as a medium charged with energy, including that of human consciousness, was diametrically opposed to the concept of confronting matter with more matter, as demonstrated by his friend, Arman, a year later. In reply to *Le Vide*, Arman exhibited *Le Plein* (Abundance), filling the entire room of Galerie Iris Clert from floor to ceiling with an accumulation of objects (p. 34).

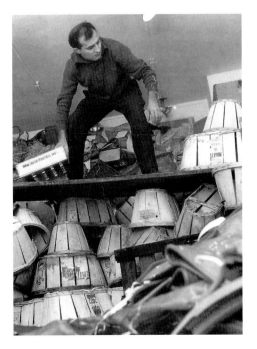

Arman preparing his exhibition *Le Plein* (Abundance), 1960
In response to Klein's *Le Vide*, Arman packed the Galerie Iris Clert from floor to ceiling with objects, making it impossible to enter the room.

- TRANSLATION

STRICTLY CONFIDENTIAL
ULTRA SECRET

"THE BLUE REVOLUTION"
Movement aiming at the transformation
of the French People's thinking and
acting in the sense of their duty to
their Nation and to all nations.

Paris, May 20th, 1958

Address: GALERIES IRIS CLERT
3, rue des Beaux-Arts,
Paris - Vme.

Mr. President EISENHOWER
White House
Washington, D.C. - U.S.A.

Dear President Eisenhower,

At this time where France is being torn by painful events, my
party has delegated me to transmit the following propositions:

To institute in France a Cabinet of French citizens (temporarily
appointed exclusively from members of our movement for 3 years), under
the political and moral control of an International House of Represent-
atives. This House will act uniquely as consulting body conceived in the
spirit of the U.N.O. and will be composed of a representative of each
nation recognized by the U.N.O.

The French National Assembly will be thus replaced by our
particular U.N.O. The entire French government thus conceived will be
under the U.N.O. authority with its headquarters in New York.

This solution seems to us most likely to resolve most of the
contradictions of our domestic policy.

By this transformation of the governmental structure my party
and I believe to set an example to the entire world of the grandeur of
the great French Revolution of 1789, which infused the universal ideal
of "Liberty - Equality - Fraternity" necessitated in the past but still
at this time as vital as ever. To these three virtues, along with the
rights of man, must be added a fourth and final social imperative: "Duty".

We hope that, Mr. President, you will duly consider these
propositions.

Awaiting your answer, which I hope will be prompt, I beg of you
to keep in strict confidence the contents of this letter. Further, I
implore you to communicate to me, before I contact officially the U.N.O.
our position and our intention to act, if we can count on your effective
help.

I remain, Mr. President,

Yours sincerely,

The "Blue Revolution", letter to President
Eisenhower, 1958
Unnerved by the turmoil in current French
politics, Klein suggested to the American
president that the forgotten ideals of 1789
could be revived by a peaceful revolution, in
which the National Assembly would be re-
placed by a popular, interim government
under international control.

Page from Klein's journal, 1958
As if warning himself against the dangers of
hubris, "humility," Klein wrote, and again
"humility."

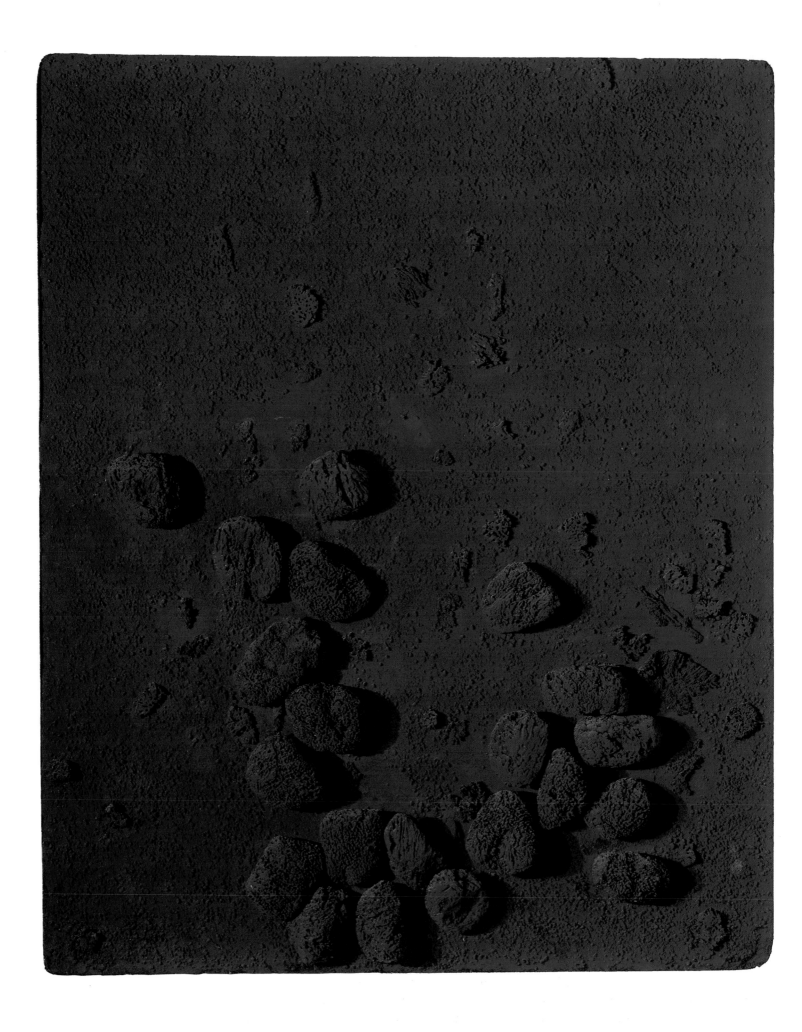

The School of Sensibility

Before deciding to use only rollers for paint application, Klein had worked with natural sponges. These he purchased, from 1956 onwards, from his friend Edouard Adam, who also supplied him with the specially developed ultramarine pigment, and who is still one of the major retailers of artists' materials in Paris.

One day Klein was struck with the beauty of a sponge soaked with blue paint, and spontaneously pressed it onto the canvas. "When working on my pictures in the studio, I sometimes used sponges," he noted in a text for his 1957 show with Colette Allendy. "Naturally they turned blue very rapidly! One day I noticed how beautiful the blue in the sponge was, and the tool immediately became a raw material. The extraordinary capacity of sponges to absorb everything liquid fascinated me." At about this time Klein created his first, small-format sponge reliefs, as designs for the decoration of a theater foyer in Gelsenkirchen, Germany. Then, in 1958, in collaboration with Vallorz and the Swiss sculptor Jean Tinguely, a close friend since *Le Vide*, he discovered a way to conserve sponges with the aid of polyester resin. The technical prerequisite for the creation of large-scale murals had been found.

The sponge as an organic growth, impregnated with his own, unique blue, seemed to Klein a perfect illustration of an "impregnation with pictorial sensibility," since sponges were naturally predestined to serve as vehicles for another, pervading element. The "Blue Epoch" exhibitions in Paris and London included a large, blue sponge sculpture, resembling a tree or a head mounted on a pedestal. The sponges, Klein explained, were intended to suggest a portrait of the viewer, a testimony to a state of interpermeating intellectual or spiritual levels. As a natural phenomenon, the sponge could be taken as a symbol of the gently alternating phases of such vital rhythms as breathing in and out, or of the transition between waking and dreaming, leading to the deep sleep that promises immersion in a timeless wisdom. Klein's *RE 16*, a large-format blue sponge relief of 1960, was inscribed *Do, Do, Do* – the singsong incantation with which French mothers lull their children to sleep. The artist had always yearned to return to a life in which homo sapiens, instead of considering himself the center of the universe, would recognize that he was merely a part of the universal design.

In the teachings of the Rosicrucians, which had preoccupied Klein since his youth, the sponge symbolizes the oceanic scope of diverse spiritual realms. This metaphor is even apt in a scientific context, for sponges illustrate a process in which the brittle remains of a once-living organism are capable of absorbing and containing great amounts of water, an element in continual flux.

Klein's reliefs are composed of saturated sponges of various size mounted on rough-surfaced panels, to create an effect evocative of the ocean floor or the topography of some unknown planet. The monochrome ultramarine blue of the compositions emanates a profound serenity, and seems to charge the surrounding space with its vibrations. On protracted view, the color is even capable of inducing a sort of waking trance. A similar state of profound mental equilibrium

Klein with a sponge relief, Gelsenkirchen, 1957–1959
Saturated with deep, monochrome blue, the reliefs seemed to charge the surrounding space with color vibrations, emanating a profound tranquillity.

PAGE 36:
RE 19, 1958

37

RE 20, Requiem, 1960
The feel and texture of natural sponges, and especially their ability to absorb and hold liquids, prompted Klein to use them both as working tools and as constituent parts of the painting surface.

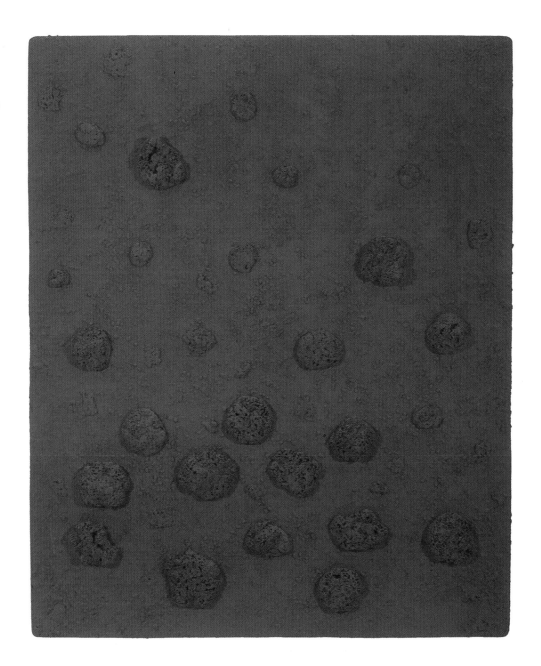

has been described by many artists and scientists of the past – and even by modern astronauts – as a source of inspiration. Richard Wagner, like Yves Klein an adept of Christian Rosenkreuz's esoteric Rosicrucianism, described the experience as follows: "I receive very distinct impressions in this trance-like state, which is a necessary condition for every creative effort. I feel that I become one with this vibrating energy, that it is omniscient, and that I can draw upon it to an extent limited only by my own, personal capabilities."

In the years 1957 to 1959, Klein's range of activities expanded when he was invited to collaborate in the project for a new theater and opera building in Gelsenkirchen. Music, drama, and the idea of a *Gesamtkunstwerk* combined to inspire the artist's first sponge reliefs on a scale that, for the period, was no less than gigantic. It is tempting to compare this organic material with Klein's intellectual curiosity, his ability to absorb impressions and impulses from the most diverse fields, and to translate them into highly personal and innovative visual forms. Unhesitatingly taking his bearings from the greats in philosophy and art – anachronism was not a word in his vocabulary – and recalling how important languages and music had been in his upbringing, Klein began to discover an affinity with Germany in general, and Wagner in particular. But in looking for some precedent to aid him in the ambitious interior design project, he did not

turn to that country's great modern architectural tradition, as might have been expected. Instead, he recalled the profound shock he had felt on seeing the frescoes in the Basilica of St. Francis, in Assisi, his first experience of Giotto's intense blue. It was this that convinced Klein that the quality of blueness was boundless, immeasurable.

As he was working on the Gelsenkirchen murals, Klein made several trips to Italy, to see the Giottos again. In these, he wrote in 1958, "the tiny, narrow gateway of world, if there is one, opens – a detail that, like all worlds, contains the signs of greatness. Greatness resides in the miniature. In Gelsenkirchen, incredible as it may seem, I have tried to create miniatures in my 20 by 7 meter paintings. This is why their relief in color can be seen to set the blue in motion, to stir it up and excite it." Then he told the theater construction committee, "I think it is justifiable in this regard to speak of an alchemy of painting, developing out of the paint material in the tension of each instant. It gives rise to a sense of immersion in a space greater than infinity. The blue is the invisible becoming visible."

The building's architect, Werner Ruhnau, had put together an international team of artists for the project, a first in Germany which the city administration

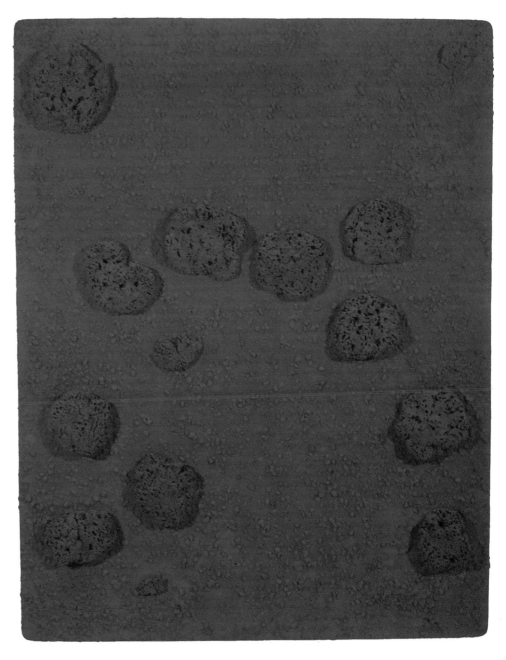

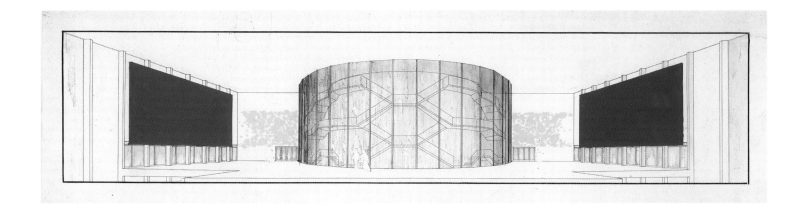

Design for the walls of Gelsenkirchen Theater
and Opera House, 1958
Klein was one of the team of international art-
ists recruited by architect Werner Ruhnau to
assist him in the construction project.

was initially reluctant to accept. The team included the two German artists Paul
Dierkes and Norbert Kricke, Robert Adams of Britain, Jean Tinguely of Switzer-
land, and Yves Klein of France. Despite difficulties at the start, the shared com-
mitment and reciprocal influence Klein experienced during the two-year project
– in which he was assisted by Rotraut Uecker, who came from Nice – opened
new horizons for his art. These included a confirmation of his concept of artistic
collaboration, which was partially inspired by the tradition of medieval building
guilds, and plans with Ruhnau to develop what they called an "Aerial Architec-
ture" and a "School of Sensibility."

The inauguration of the theater in December 1959 amounted to an official
triumph of monochrome art. The space of the two-story foyer was dominated by
Klein's blue, emanating from two enormous blue reliefs on the side walls (20 x
7 m each), two adjacent reliefs of layered sponges on the rear wall (10 x 5 m
each), and two further blue relief murals in the cloakroom (9 m in length). Over-
joyed by the results, Klein said he had succeeded in conjuring up a magical
atmosphere for the theater audience.

The project was followed, in 1959, by another exhibition with Iris Clert, a
series of bas-reliefs embedded in a forest of sponges. From this point onwards,
Sponge Sculptures (pp. 44 and 45) and *Sponge Reliefs* (pp. 36–39), versions of
which he later produced in red and gold (pp. 46 and 47), played a role in Klein's
œuvre rivalling that of the monochrome paintings.

The same period saw the conception of a *Sculpture Aéro-Magnétique*, a
sponge sculpture floating freely over the base, as part of Klein's plans for an
artistic conquest of the air. In analogy to aeronautics and space-travel, he be-
lieved, the potential energy contained in the atmosphere could be exploited for
artistic ends. Similar conceptions of space and time were being advanced by
many international artists of the period, including Jesus Raphael Soto and
Yaakov Agam (both also represented by Iris Clert), by Lucio Fontana, and sub-
sequently by the Zero group in Germany and kinetic artists worldwide.

To work out his ideas of "Aerial Architecture" and a "climate-controlled
earth," Klein had found the ideal partner in Ruhnau, who was receptive to his
long-cherished vision of a union of humankind with the cosmos. First steps in
this direction were taken with various designs for an architecture consisting of
air, water, and fire. Klein explained the joint project in a now-famous lecture,
"Conférence à la Sorbonne" (cf. p. 48): "In the course of all of these investiga-
tions into an art aimed at dematerialization, we met, Werner Ruhnau and I, when
we discovered aerial architecture. The final obstacle that Mies van der Rohe was
not able to overcome disturbed [Ruhnau] and caused him difficulties – the roof,
which separates us like an umbrella from the sky, from the blue of the sky. And I
was bothered by the [wall] surface – the tangible blue on the canvas – which pre-
vents people from gazing constantly at the horizon. This dream-like state of
static trance was probably experienced by humans in the biblical Eden. Human

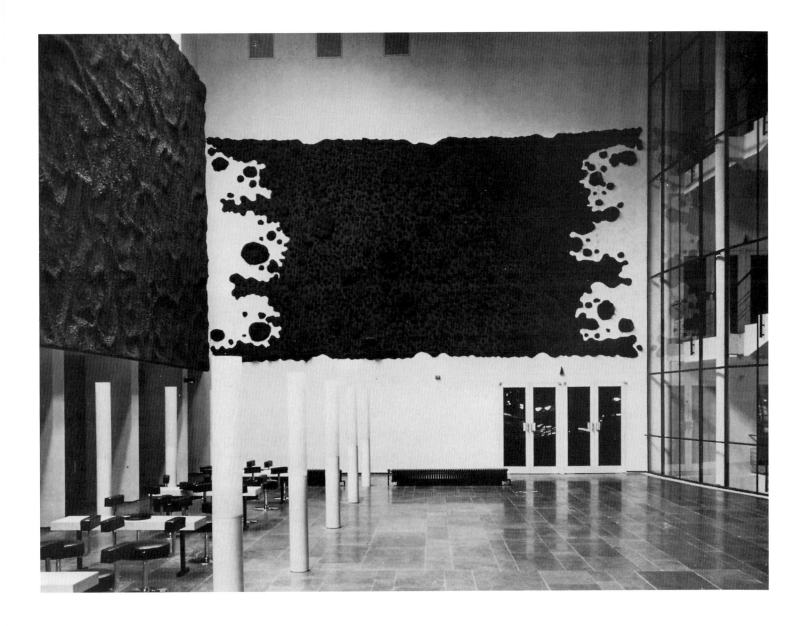

Foyer of Gelsenkirchen Theater and Opera
House, 1959
In a triumph of monochrome art, Klein in-
stalled six large-scale blue reliefs in the spa-
cious, two-story foyer.

beings of the future, integrated in total space, participating in the life of the
universe, will probably find themselves in a dynamic state like a waking dream,
with an acutely lucid perception of tangible and visible nature. They will have
achieved complete physical well-being on terrestrial earth. Liberated from a
false conception of their inner, psychological life, they will live in a state of ab-
solute harmony with invisible, insensible nature; or in other words, with life it-
self, which has become concrete by a reversal of roles, that is, by means of ren-
dering psychological nature abstract."

As with Ruhnau, Klein had once before felt a sense of immediate mutual
understanding with another artist: Jean Tinguely, whom he met in April 1958, on
the occasion of *Le Vide* (p. 42). Tinguely, who had been making electromechan-
ical kinetic reliefs since 1953, was so impressed by *Le Vide* that he returned day
after day to spend time in the "empty" room. The friendship between the two
artists soon developed into a close artistic collaboration. Although their first
kinetic object, intended for the Salon des Réalités Nouvelles of May 1958, re-
fused to work, a few months later they were already able to mount a joint exhibi-
tion of recent pieces.

"Vitesse pure et stabilité monochrome" (Sheer Speed and Monochrome Sta-
bility) took place in November 1958, at the Galerie Iris Clert. As invitations,
Klein made a number of blue disks for a motor base by Tinguely which, spin-
ning them at 2500 to 4500 revolutions per minute, engendered a virtual blue vi-
bration in the air. The effect of the objects in the show depended on a reciprocal

41

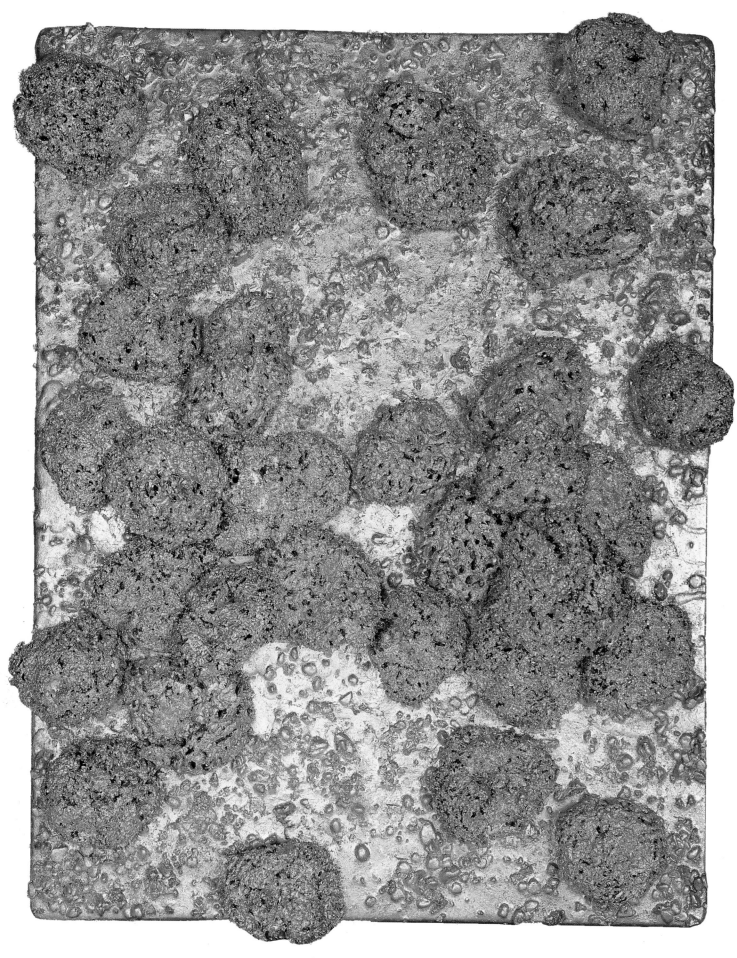

RE 33, The Gilded Spheres, c. 1960

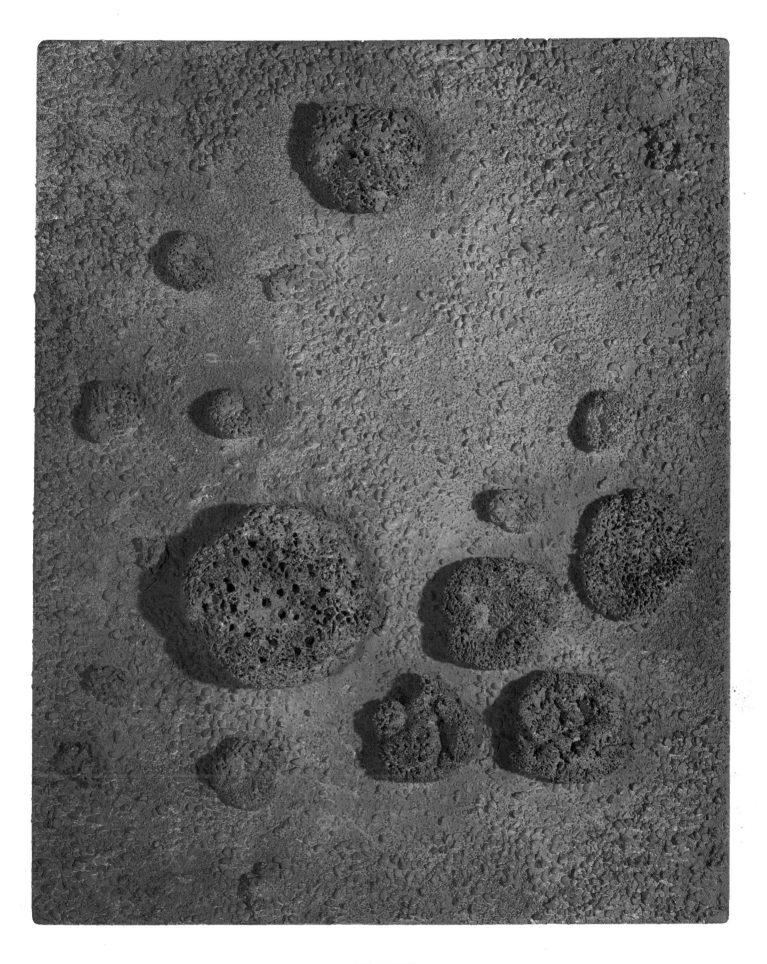

RE 26, 1960

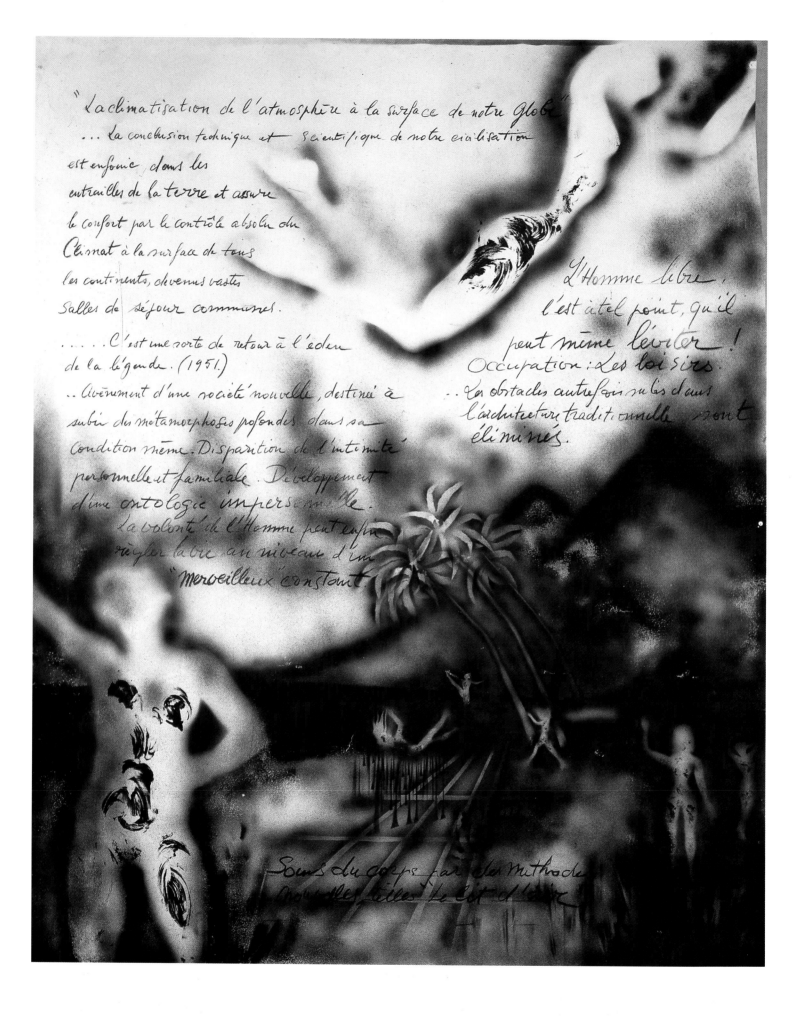

"L'acclimatisation de l'atmosphère à la surface de notre Globe"

... la conclusion technique et scientifique de notre civilisation

est enfouie dans les

entrailles de la terre et assure

le confort par le contrôle absolu du

Climat à la surface de tous

les continents, devenus vastes

salles de séjour communes.

...... C'est une sorte de retour à l'éden
de la légende. (1951.)

.. Avènement d'une société nouvelle, destinée à
subir des métamorphoses profondes dans sa
Condition même. Disparition de l'intimité
personnelle et familiale. Développement
d'une ontologie impersonnelle.

La volonté de l'Homme peut enfin
régler la vie au niveau d'un
"merveilleux" constant.

L'Homme libre,
l'est à tel point, qu'il
peut même léviter !
Occupation : Les loisirs.
.. Les obstacles autrefois subis dans
l'architecture traditionnelle sont
éliminés.

Soins du corps par des méthodes
nouvelles telles le lait d'air

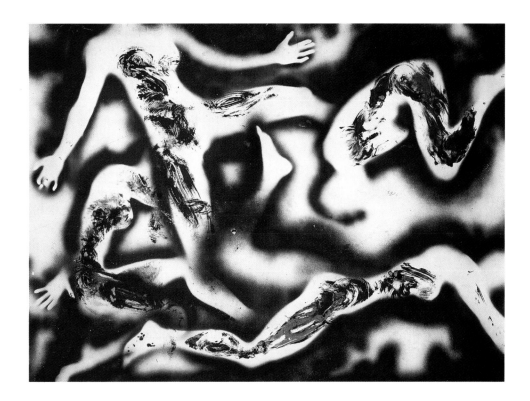

ANT 63, 1961

ANT 102, Aerial Architecture, 1961
With his utopian vision of an "architecture of the air," which would eliminate the obstacles set up by traditional architecture, Klein lent shape to his dream of contributing to global reconciliation and harmony.

cal paradise. In *Aerial Architecture* of 1961 (p. 60), he symbolically outlined his entire program for taming the earth's climate, including changing weather and environmental conditions. Beneath a cluster of palms evoking the Garden of Eden, a female figure reclines on jets of air issuing from the ground, as other figures float around her in a kind of galactic space.

Between the two large, foreground figures runs a handwritten text that states the premises of aerial architecture: "The climatization of the atmosphere on the surface of the globe. The technological and scientific results of our civilization are concealed in the entrails of the earth, and assure comfort by means of an absolute control of the surface climate on all continents, which have become vast, communal living rooms... It is a sort of return to the Eden of legend (1951). Advent of a new society, destined to bring about profound metamorphoses. A disappearance of personal and familial privacy. The development of an impersonal ontology. Human will-power at last in a position to regulate life at the level of a permanent 'miracle'. Man liberated to the point of being able to levitate! Occupation: leisure. The obstacles raised by traditional architecture have been eliminated."

This utopian vision of an architecture built of sheer energy reflected a new facet of Klein's dream of contributing to global reconciliation. Looking back to the age of innocence, he yearned for a humane, if technologically and economically advanced paradise on earth. He would undo the temptation of Eve, that fateful bite into the apple that brought a knowledge of good and evil, and the resulting dichotomy between conscious and unconscious, which Klein viewed as an illogical confutation of mind and matter. In Restany's eyes, the great, weightlessly hovering *Anthropométries* of the artist's two final years contained "the allusive trace of anti-matter in matter."

This interpretation applies in a special way to a large-format work indicatively titled *Hiroshima* (p. 62). Its technique alone makes it unique, for this is the only Anthropométrie of the final years to consist solely of negative impressions. The composition is built up of silhouettes in various poses, shadowy blue figures that appear to levitate in deep blue space. Here the presence of the flesh is transmuted into its reverse, the absence of mass death, the ghostly traces of a memory indelibly engraved in the world's mind.

Pierre Restany with his book, *Yves Klein. Le Monochrome*, November 1961

BOTTOM LEFT:
Founding manifesto of the Nouveaux Réalistes: "On Thursday, 27 October 1960, the Nouveaux Réalistes became conscious of their collective singularity. New Realism = new perceptual approaches to the real."

BOTTOM RIGHT:
The Nouveaux Réalistes visiting Yves Klein: Arman, Jean Tinguely, Rotraut Uecker, Daniel Spoerri, Jacques de la Villeglé and Pierre Restany, 1960

Klein, Martial Raysse, Daniel Spoerri, Jean Tinguely, and Jacques Mahé de la Villeglé (p. 65), who were later to be joined by Niki de Saint-Phalle, Christo, and Deschamps. A founding manifesto was issued, in seven copies on monochrome blue paper, and on one sheet each of monochrome pink and gold (p. 64, bottom left).

The first full-scale public appearance of the Nouveaux Réalistes came in 1960, with an exhibition at Galleria Apollinaire in Milan. Their declared principal aim was to present reality as a "realistic work of art," with the artist's creative activity itself constituting the manifestation and actual subject of the work. The artist's sensibility, instead of lending things aesthetic shape, would express itself solely through a selection and presentation of certain existing realities. Restany, initiator and mentor of the group, also formulated its guidelines. He spoke, for instance, of an "urban folklore" and, with reference to the neo-realistic *Accumulations* of Arman and Spoerri, of "quantitative instead of qualitative expression."

In 1961, under the heading "A 40° au-dessus de Dada" (Forty Degrees above Dada), Restany mounted a collective show at his own Galerie J. Aimed at defining the intellectual position of the Nouveaux Réalistes, the show paid homage to the great achievements of anti-art and Dada, while demonstrating that these had been overcome and carried a step further. As Restany himself put it, "The fever of the Nouveaux Réalistes is the fever of poetic discovery: dadaist 'readymades' on the scale of modern miracles."

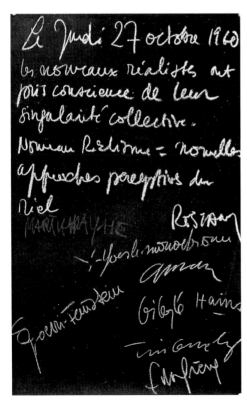

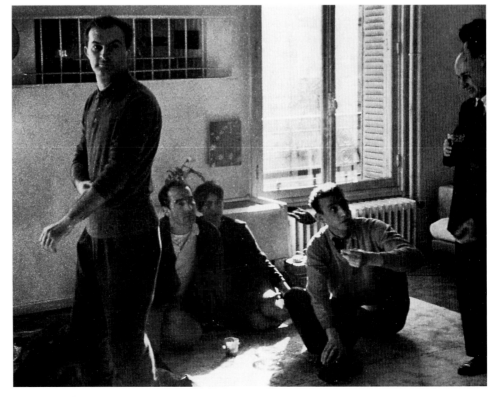

Jacques de la Villeglé
Rue au Maire, 1967
One of the founding members of the Nouveaux Réalistes, de la Villeglé
early discovered what he called the "poésie murale," the poetry of walls.
The texture of a peeling billboard, a décollage, frames a sheet of blue
which calls up many associations with everyday French life – cigarette
packages, police uniforms, royalist blue, or the revolutionary blue of the
tricolor – while remaining a quote from reality.

IKB 191, 1962
This blue monochrome canvas is an homage to Pierre Restany, who from
their first meeting, in 1955, provided Klein's œuvre with literary and the-
oretical underpinning. His collaboration with the French art critic, which
Klein termed an experience of "direct communication," was to materially
further a general understanding of his art beyond his lifetime.

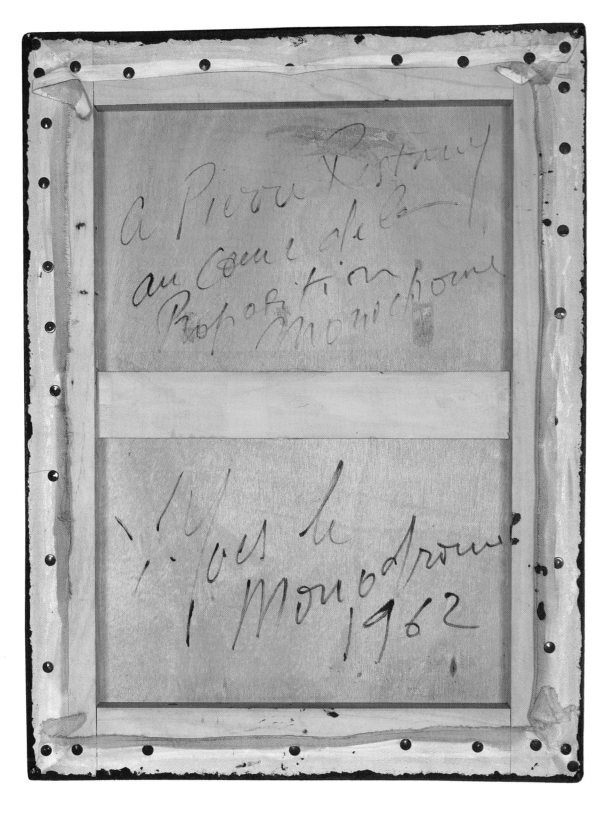

IKB 191, 1962
Reverse with dedication:
"For Pierre Restany, at the heart of the monochrome proposition,
Yves le Monochrome, 1962"

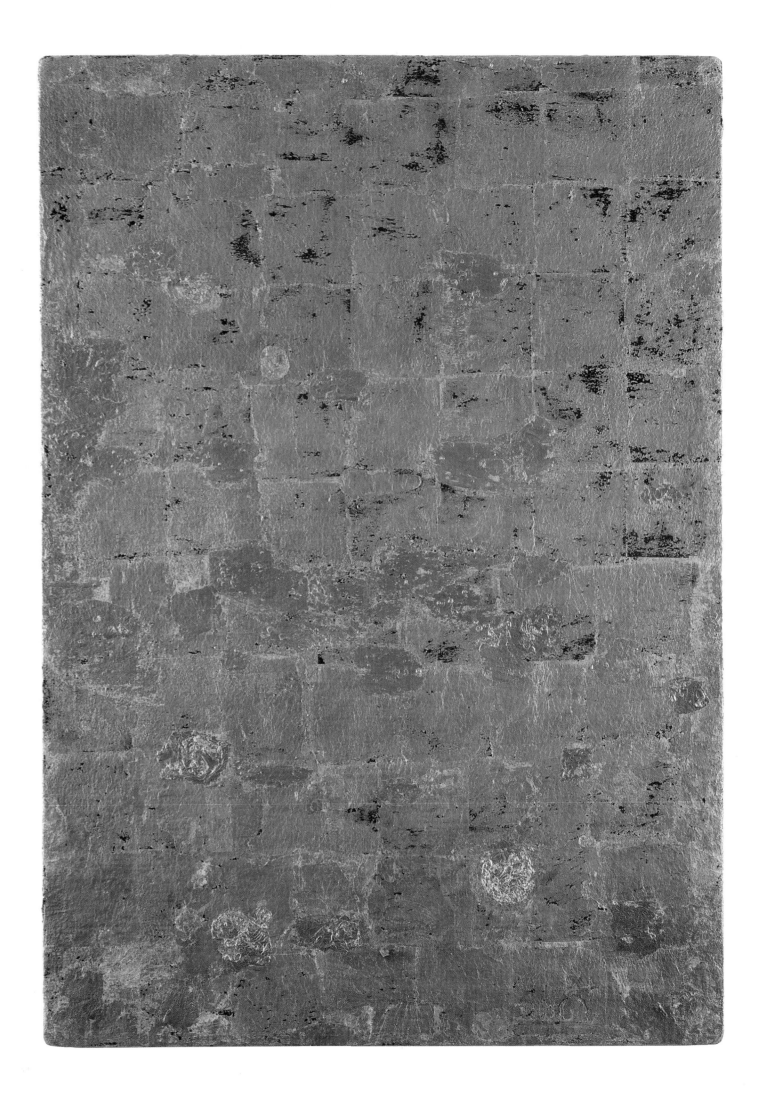

Monochromes and Fire Paintings

The year 1960 saw Klein focussing on the poignancy of color, as he supplemented his famous blue with pink and gold. The new colors now made their appearance in all of the media he had worked in – monochrome paintings, sculptures, and sponge reliefs. It was gold in particular that challenged him to new heights of technical mastery.

Klein had learned the technique of gilding in London in 1949, and was awed at the potentials of this costly and difficult material. What especially fascinated him was the fragile nature of "the exquisite, delicate gold, whose leaves flew away at the slightest breath." For the medieval alchemists, the search for a way to make gold corresponded to a search for the philosopher's stone. Their attempts to combine chemically what they called earthly and heavenly elements, apart from the pragmatic aim of transforming base metals into the most precious currency, gold, were informed by a higher, metaphysical idea – that of the enlightenment and salvation of mankind.

But to return to Klein, and to the ambitious and expensive projects for which, it should be recalled, he never had enough ready cash. Naturally this was a problem faced by many young artists, then as now. But according to Klein's friends and his wife, Rotraut, his difficulties were compounded by the fact that he was working on an ever larger scale, and could not afford to rent a studio. Yet the pressures of need evidently served to fuel his imagination still more. And, as Samy Tarica, a Paris collector, reports, Klein had a great power of persuading people that it was more than self-interest that led him to suggest a new exchange system for contemporary art that would reflect new and more sensitive forms of social interaction.

This notion drew from various value systems of the past. It reflected an awareness of the history of ideas, in which gold, beyond its material value, invariably possessed a profound spiritual and metaphysical meaning – recall the golden domes of Byzantium, or the gilt grounds of medieval painting. The aim of Klein's artistic transactions was to reinstate gold, and by analogy, money, in this symbolic function, and to break us of the habit of considering it a mere means of exchange for commodities, particularly works of art.

In a solemn ritual witnessed by museum staff, for instance, Klein sold *Zones of Immaterial Pictorial Sensibility* to friends, fellow artists, and patrons. The purchase price was to be paid in gold or gold ingots, half the value of which the artist promised to return, in one way or another, to nature and humanity, to "the mystical circulation of things."

One such transaction, photographically recorded, took place on 10 February 1962. For the surrender of "his pictorial sensibility," the Blankforts, an American couple, gave fourteen gold ingots to Klein, who thereupon threw seven of them into the Seine. The other half of the purchase price was later converted into gold leaf for his works, the *Monogolds* (p.68).

Using a specially developed technique, the fine gold leaves in these works

Klein in the regalia of the Knights of St. Sebastian

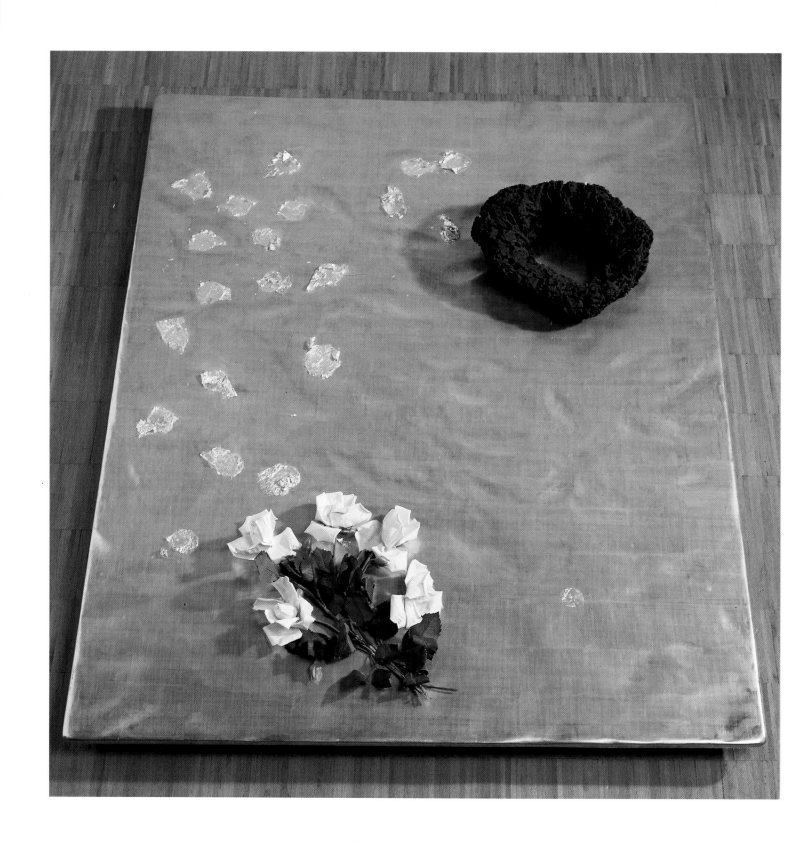

A Life like a Continuous Note

There is an early page in Klein's journal on which he wrote, in a kind of intimate monologue, the one word "humilité" over and over again (p. 35). Humility, to be sure, but not the ordinary, daily humiliations which can be so wounding to a sensitive artist. In the course of his brief life, Klein developed an extraordinary charisma. Thanks to his athletic figure and a mind receptive to the wonderful and mysterious aspects of existence, he exuded the aura of a youthful hero, like some irresponsibly innocent messenger of the gods. He seemed to move in a higher realm than ordinary mortals, which is why he could say, "My paintings are the ashes of my art." Yet although he devoted his entire œuvre to the harmony and beauty of a potential future culture, Klein himself felt continually exposed to loneliness and death. This constant awareness of mortality expressed itself in his art, as critic Ulf Linde has said, by "the presence of absence." This explains the vital importance Klein attached to having his art understood as an attempt to transcend the personal. As he stated as early as 1959, at the opening of Tinguely's exhibition in Düsseldorf: "The message I carry within myself is that of life and nature; and I invite you to participate in it, to the same extent as my friends, who know my ideas better than I do myself – because they are the many, and can reflect on them with greater diversity, because I am alone."

Newly married and at the apex of his artistic success, Klein experienced the extremes of Eros and Thanatos in rapid succession. First, on 1 March 1962, came the delicately lyrical note of a *Store-poème* (Scroll Poem). As if drawing the lines of his life together, Klein combined poetry by his closest friends, Claude Pascal, Arman, and Pierre Restany, with imprints from the model, Héléna, on a linen shroud almost fifteen meters in length. It was like a souvenir of the unique, irretrievable moments of their past collaboration. Then, a short time later, on 31 March, Klein spontaneously called a photographer in to take a picture of him lying on the floor, underneath *RP 3, Here Lies Space*, a 1960 relief evocative of the solar system (Musée National d'Art Moderne, Paris; pp. 80 and 81). In a ritual of anticipation, Klein asked his wife to scatter roses on the work of art as last resting place. Half in jest, perhaps half in a kind of magical incantation, he said he wanted his artistic spirit to partake in the myth of eternal presence beyond the grave.

In the final phase of his career, apart from spending more time with his close friends, Klein developed a new series of images relating to the earth's surface. As early as 1957, he had already conceived a *Blue Globe* with mountain ranges indicated in relief, based on the characteristic idea of capturing in art everything known, and yet to be discovered, about the planet (p. 83). Here, as in all of his subsequent imagery, Klein's prime interest lay in the phenomenology of human imagination. Out to evoke a unity of heaven and earth, he methodically developed forms of visual heightening coupled with an extreme reduction of means. At the time, this approach was completely unprecedented. And, as at every later stage of his art, it addressed the point at which the limits of percep-

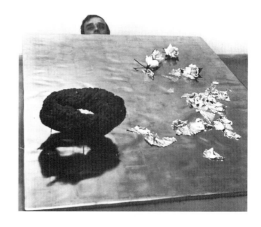

Klein lying under *Here Lies Space*, 1960
The artist had this prescient photograph taken on 3 March 1962, a few weeks before his death. Half in jest, half in an attempt to ward off the inevitable, he asked his wife to scatter a wreath of roses on the grave.

PAGE 80:
RP 3, Here Lies Space, 1960

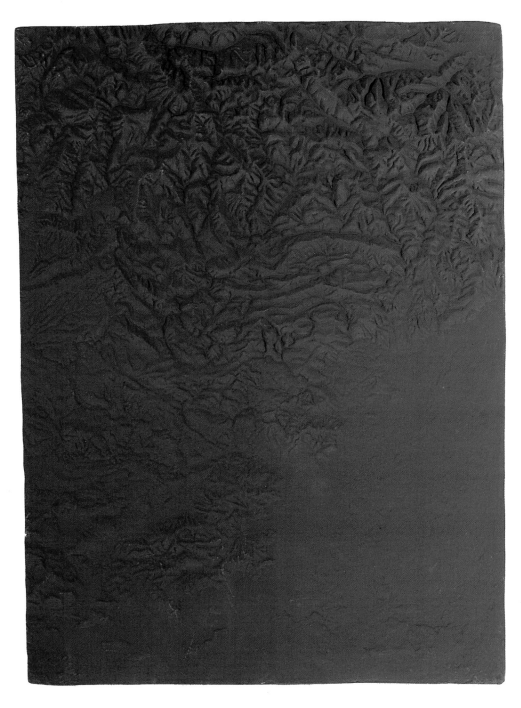

RP 10, 1961
"I have chosen as my ally the palpable space of the entire, boundless universe. This is the first time that anyone has taken it into account. It's like finding the master key."
Yves Klein

the contemporary age which were situated at that borderline where borders dissolve and the known merges with the unknown. "Art... is not some inspiration that comes from who knows where, takes a random course, and presents nothing but the picturesque exterior of things. Art is logic *per se*, adorned by genius, but following the path of necessity, and informed by the highest laws," to requote that key entry in Klein's diary for 1958.

The statement contains the essential, defining antipodes of his artistic existence. On the one hand, it describes the gratuitous nature of inspiration, which comes in a reverie only to fade again, leaving behind an intangible but lastingly illuminating aura. On the other hand, the statement refers to the logical values that inform the Western tradition, particularly the chain of cause and effect. Klein also alludes in passing to the distinction he always drew between talent and genius, the latter of which he felt at work within himself, a romantic ecstasy that led him on a quest for a present that fulfilled the highest laws.

In early 1962 Klein was entirely preoccupied with the idea of creating a Garden of Eden on earth. He envisioned a temperate zone of gardens and lakes, in-

terspersed with fire and water sculptures shooting into the air, symbolically uniting the fundamental elements. As culmination of this landscape, Klein planned a magnificent frieze along classical lines, composed of figures in a noble pose that would express the character of a more humane culture to come. These were to be based on life-size casts of himself and his artist-friends, depicted nude in a frontal, static pose, with head turned slightly aside, and arms with clenched fists resting at their sides. The figures were to end at the thighs – that is, like many of Klein's earlier pieces, to have no apparent visible support. Flanked by bronze castings of his friends in ultramarine blue before a gilded ground, his own figure would gleam at the center, in gilt bronze against blue.

Klein commenced the project in February 1962, making plaster casts of his closest and oldest friends from Nice – Arman, Martial Raysse, and Claude Pascal. The electrifying effect of the blue-gold contrast was conceived in the ancient tradition of color symbolism seen in Byzantine and Egyptian art, or in Buddhist temples. The resulting portrait reliefs, like that of Arman (p. 87), possess an extreme tension; the mutual attraction and repellence exerted by the blue and gold engender a forcefield of mental associations and emotions. While the burnished gold surface reflects everything and absorbs nothing, the matte blue of the figures causes them to recede, seemingly depriving the individuals depicted of corporeal presence. The pieces have the effect of timeless detachment, and yet the life that still clings to the empty human shell makes them magically compelling.

In sum, these final works of Klein's might be characterized as a sublimation of the personal aura, a transformation of physical sensuality into the inviolable if ineffable presence of enduring artistic values. Significantly, his *Portrait Relief of*

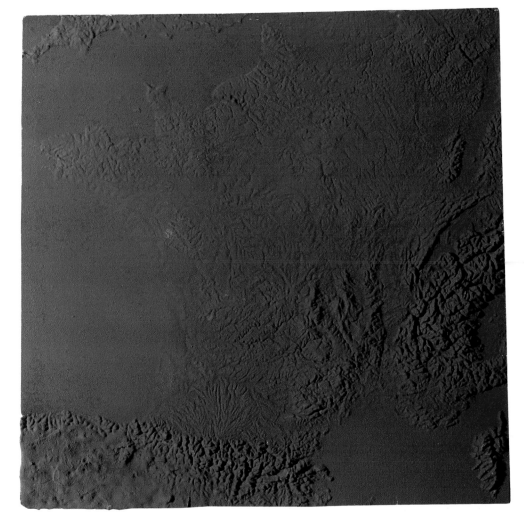

RP 18, 1961

68
MG 18, 1961
Gold leaf, pigment and synthetic resin
on cotton on wood, 78.5 x 55.5cm
Cologne, Museum Ludwig

70
Ex Voto for the Shrine of St. Rita in Cascia, 1961
*Ex-voto offerte par Yves Klein au sanctuaire de Saint
Rita de Cascia*
Pigment and gold in plexiglass
Cascia Convent

71
IKB 75, MG 17, MP 16: Blue-Gold-Pink Trilogy, 1960
Trilogie bleue-or-rose
Pigment, gold and synthetic resin on wood,
each 199 x 153cm
Humlebæk, Louisiana Museum of Modern Art

72 top
Charles Wilp
Yves Klein with the architect Werner Ruhnau
behind his *Fire Wall*, 1961
Photograph
Berlin, Bildarchiv Preussischer Kulturbesitz

72 bottom
Fire Wall and Fire Sculpture, 1961
Sculpture de feu et Mur de feu
Fire performance at Museum Haus Lange, Krefeld

73
F 43, 1961
Traces of fire from the Fire Wall and Fire Fountain,
70 x 100cm
Private collection

74 top
F 25, 1961
Fire imprint on Swedish cardboard, 200 x 152cm
Private collection

75 top left
F 36, 1961
Fire imprint on Swedish cardboard, 119 x 79.5cm
Private collection

75 top right
F 6, 1961
Traces of fire and paint on cardboard on wood,
92 x 73cm
Private collection

75 bottom left
F 31, 1961
Fire imprint on paper, 61 x 39cm
Private collection

75 bottom right
F 26, 1962
Traces of fire on cardboard and wood,
73 x 54cm
Private collection

76 top
Mark Rothko
Number 101, 1961
Oil on canvas, 200.7 x 205.7cm
Collection Joseph Pulitzer Jr.

76 bottom
Malevich, or Space Seen from a Distance, undated
Malevitch ou l'espace vu de loin
Pencil on paper
Estate of Yves Klein

77
MP 19, 1962
Pigment and synthetic resin on canvas on wood,
92 x 73cm
Private collection

78 top
Yves Klein/Christo
Wedding Portrait, 1962
*Portrait de Rotraut et Yves Klein le jour
de leur mariage*
Oil on canvas, 213 x 148cm
Nice, Musée d'Art Moderne et d'Art Contemporain

79
MG 25, 1961
Gold leaf on canvas on plywood, 53.5 x 50.4cm
Munich, Sammlung Lenz Schönberg

80
RP 3, Here Lies Space, 1960
Ci-gît l'espace
Gold leaf on hardboard with blue sponge
and artificial roses, plywood, 125 x 100cm
Paris, Musée National d'Art Moderne,
Centre Georges Pompidou

82
Harry Shunk
The Earth Is Blue, c. 1961
La terre est bleue
Photograph
Estate of Yves Klein

83
RP 7, Blue Globe, 1957
Le globe terrestre bleu
Pigment on globe, 19 x 12cm
Private collection

84
RP 10, 1961
Pigment and synthetic resin on polyester
and fiberglass, 86 x 65cm
Private collection

85
RP 18, 1961
Plaster on plywood, relief cast of map of France,
58 x 58cm
Paris, Collection M. et Mme Philippe Durand-Ruel

86
PR 3, Portrait Relief of Claude Pascal, 1962
Pigment on plaster cast mounted on gilt plywood,
175.5 x 94 x 26cm
Private collection

87
PR 1, Portrait Relief of Arman, 1962
Bronze cast, painted blue, mounted on gilt plywood,
176.5 x 94 x 26cm
Paris, Musée National d'Art Moderne,
Centre Georges Pompidou

89
Harry Shunk
Yves Klein, 1962
Photograph
Estate of Yves Klein

The publishers wish to thank the museums, archives and photographers for their kind permission to reproduce the illustrations and for their support and encouragement in the preparation of this book. In addition to the collections and institutions named in the captions, the following acknowledgements are also due:

Bildarchiv Preussischer Kulturbesitz, Berlin: 12 top, 32 top left, 33 top right, 72 top:
Christian Leurri: 41;
Musée National d'Art Moderne, Paris: 7, 9 top, 12 bottom, 16, 20 left, 29, 38, 39, 43 bottom, 45 top, 45 bottom, 54 top, 54 bottom, 56 top right, 62, 63, 69, 76 bottom, 80, 83, 84, 87, 90 bottom right;
Musée National d'Art Moderne, Paris, Photo: Harry Shunk: 42 bottom;
Estate of Yves Klein, Rotraut Moquay-Klein and Daniel Moquay, Paradise Valley, AZ: 1, 2, 6, 9 bottom, 10, 13 top, 13 bottom, 17 top, 17 bottom, 18, 19, 20, 21, 22, 24 bottom, 25, 26, 27 top, 30, 31, 32 top right, 32 bottom right, 33 top left, 33 bottom left, 35 left, 35 right, 40, 42 top, 43 top, 44, 46, 47, 49, 52, 56 top left, 56 bottom left, 57, 59, 60, 61, 64 top left, 64 bottom left, 66, 67, 70, 72 bottom, 73, 74 top, 74 bottom, 75 (all), 77, 85, 86, 88, 90 bottom left, 90 bottom middle, 91 top left, 91 top right
Rheinisches Bildarchiv, Cologne: front cover, 36, 68;
Sammlung Lenz Schönberg, Munich: 17 middle, 23, 56 bottom right, 79;
Harry Shunk, New York: 20 right, 24 top, 27 bottom, 37, 50, 51, 55, 64 bottom right, 78 bottom, 81, 82, 89, back cover;
Christine Traber, Berlin: 78 top.

In this series:

- Arcimboldo
- Bosch
- Botticelli
- Bruegel
- Chagall
- Christo
- Dalí
- Degas
- Delaunay
- Ernst
- Gauguin
- van Gogh
- Grosz
- Hopper
- Kahlo
- Kandinsky
- Klee
- Klein
- Klimt
- Lempicka
- Lichtenstein
- Macke
- Magritte
- Marc
- Matisse
- Miró
- Monet
- Mondrian
- Munch
- O'Keeffe
- Picasso
- Rembrandt
- Renoir
- Rousseau
- Schiele
- von Stuck
- Toulouse-Lautrec
- Turner
- Vermeer
- Warhol